ROY LICHTENSTEIN
AMERICAN INDIAN ENCOUNTERS

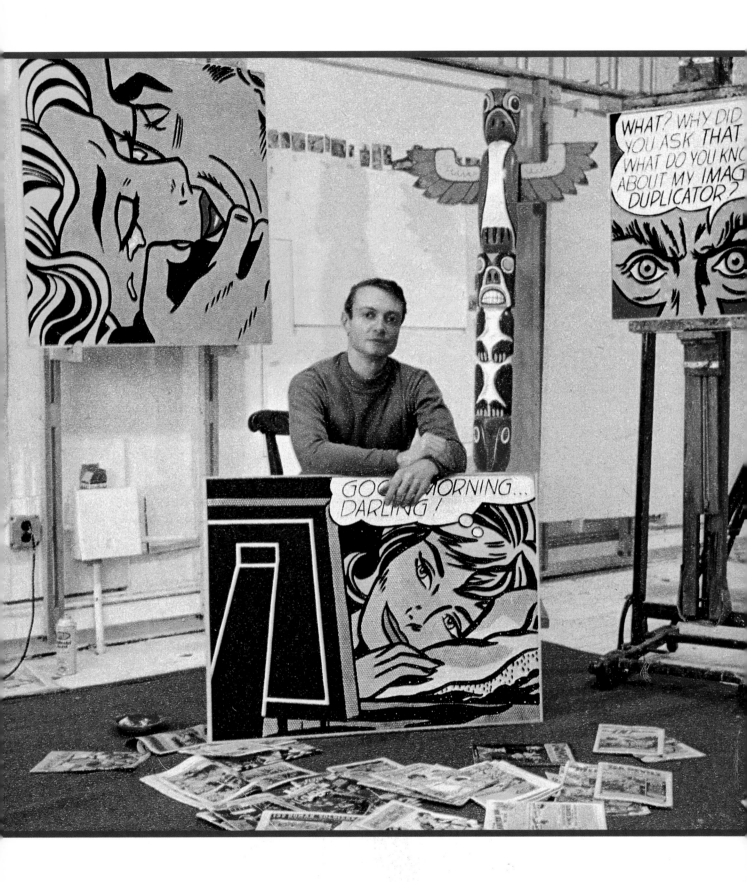

ROY LICHTENSTEIN
AMERICAN INDIAN ENCOUNTERS

by Gail Stavitsky and Twig Johnson

Montclair Art Museum
October 16, 2005 – January 8, 2006

Museum of Fine Arts, Museum of New Mexico
February 2 – April 22, 2006

Tacoma Art Museum
May 13 – September 4, 2006

The Parrish Art Museum
September 24 – December 31, 2006

Eiteljorg Museum of American Indians and Western Art
January 19 – April 18, 2007

ISBN 978-0-8135-3738-2

Library of Congress Control Number 2005930901

Distributed by: Rutgers University Press
Design: Rich Sheinaus, Gotham Design, NYC
Printer: Friesens Press

Roy Lichtenstein: American Indian Encounters **presented by the Blanche and Irving Laurie Foundation** is organized by the Montclair Art Museum in conjunction with the Roy Lichtenstein Foundation. The exhibition and catalogue are supported by a generous grant from the Blanche and Irving Laurie Foundation, the Karma Foundation, and from the following Exhibition Angels: Anonymous, Dorothea and Peter Frank, Gregg Seibert, and Judith and William Turner. Additional support has been provided by Adrian Shelby and Jacqueline and Herb Klein.

The Blanche and Irving Laurie Foundation celebrates its 22nd anniversary this year. Since its inception in 1983 the Foundation has distributed more than $35,000,000 to charitable organizations serving the community in the Foundation's major interest areas of the arts, education, human needs and a variety of Jewish causes. The Foundation is equally proud of its collaborative efforts with its philanthropic partners in the design and evaluation of its grants, in the nurturing of a shared commitment to the task at hand, and to the overall institutional growth of the supported organizations. While the Foundation has concentrated its grant making activities in New Jersey, substantial attention has been paid to the support of major cultural instututions outside of New Jersey whose programming activities enhance the lives of residents of the region. In addition to presenting the Montclair Art Museum's **Roy Lichtenstein: American Indian Encounters** exhibition this year, the Foundation's program of cultural support also includes the Roundabout Theatre's production of *The Threepenny Opera*, Lincoln Center Theatre's production of Wendy Wasserstein's *Third*, WNET's *American Masters* series, and City Center's *Encores!* series. The Foundation was gratified to have been selected as the Outstanding Foundation of 2004 by the New Jersey Chapter of the Association of Fundraising Professionals.

All Museum programs are made possible, in part, by the New Jersey State Council on the Arts/Department of State, a Partner Agency of the National Endowment for the Arts and by funds from the National Endowment for the Arts; the Geraldine R. Dodge Foundation; and Museum members.

Front cover: *Little Landscape*, 1979, Oil and Magna on linen, 36 x 48 in., Private Collection

Back cover: *Two Sioux*, 1952, Oil on canvas, 30 x 22 1/16 in., Private Collection

Frontispiece: *Fig. 9*, Roy Lichtenstein, 1964 in his studio at 36 West 26th St. in Manhattan sitting behind his painting, *Good Morning...Darling!*, 1964. Other works pictured (left to right): *Kiss V*, 1964, a totem pole, and *Image Duplicator*, 1963. Photograph originally published in *Epoca* (Milan) (May 17, 1964). Photo: © Mario di Biasi De Biasi/Mondadori

Table of Contents

Foreword and Acknowledgements

Though one might think, given the national pride of the United States, that this country's art museums devoted just to American and Native American art would be numerous, there are very few. The Montclair Art Museum is nearly singular in its focused devotion to American and American Indian art and an exhibition and educational program that gives these dual, diverse cultures parity. In recent years the Montclair Art Museum has sought ways to interconnect and integrate its paired artistic expressions. We are therefore pleased to be organizing and presenting this exhibition of two related little-known bodies of work by the major American artist Roy Lichtenstein that were strongly influenced by Native American motifs and imagery. They had been overshadowed by the prodigious parade of themes and subjects that make Lichtenstein's Pop art so dazzling.

A few months after I became director of the Montclair Art Museum in September 2001, I contacted Jack Cowart, Executive Director of the Roy Lichtenstein Foundation, about the possibility of borrowing one of the Pop master's American Indian or cowboy images to exhibit here. I knew that among his many subjects, Indian and cowboy imagery had been a topic and I was aware of the Lichtenstein Foundation's openness and generosity. In October 2002, Jack Cowart suggested the possibility of a much bigger collaboration: a show of Lichtenstein's many works in the 1950s and then in the late 1970s that used Native American subjects and themes. Our chief curator, Gail Stavitsky, and Curator of Native American Art, Twig Johnson immediately shared my enthusiasm. We scheduled a trip to the Foundation to visit with Jack and with Dorothy Lichtenstein, the artist's gracious, charismatic widow. Jack was

prepared with an amazing number of color printouts of Lichtenstein's Native American themes and subjects. Dorothy's recollections were vital links to the past; she also showed special kindness in giving Gail and Twig access to her husband's art books. These books are the inspiration of so much of Lichtenstein's reproduction-driven art. It was quickly clear that a fascinating and fresh show could be organized that would be a genuine contribution to the understanding of this seminal American artist. Such an exhibition would make the much neglected and, even by the artist, dismissed 1950s early work and the later Amerindian series into the stars of a fresh, innovative and insightful view of a celebrity artist whose sensibility has so deeply permeated modern visual culture.

In my colleagues Gail Stavitsky and Twig Johnson, these neglected works found impassioned advocates and dedicated scholars and researchers. We were all fascinated by the depth of American Indian imagery to be found in Lichtenstein's art, yet little verbal evidence from the artist of any enthusiasm for it. This confirmed again Lichtenstein's characteristic diffidence. His commitment to the cultures and artists he deploys in his work can only be detected in the fact that he has chosen to appropriate them. The spirituality and deep cultural power of Native American art, its pre-1890s creation of objects without any market consideration, does not factor into Lichtenstein's use of these motifs. In a way, Lichtenstein de-cultures his Native American images in ways that really require rethinking our cultural assumptions. His subversion is very barbed, but is conveyed with blandness and seeming neutrality. Their joint research, aided by pioneer doctoral dissertations by

Dr. Ernst A. Busche and Brenda Schmahmann, has provided a depth of iconographic sourcing that allows the 1950s work to be seen as more than insignificant pre-Pop efforts. This project allows us to see and better understand Lichtenstein's 1950s works as potent precursors of the profundities of his post-modernist aesthetic. The compacted iconography of his Amerindian series turns charged and often spiritual motifs from multiple Native North and South American cultures into artistic visual data and contemporary abstractions.

Our enthusiasm for this project was endorsed by the crucial and generous support of the New Jersey-based Blanche and Irving Laurie Foundation, which awarded the Museum the largest funding for a single exhibition project in its history. The Foundation's director Gene R. Korf showed great personal kindness in helping us develop the appropriate request. This recent Blanche and Irving Laurie Foundation beneficence follows major funding for the Museum's Capital Campaign, happily manifested in the Museum's lively Blanche and Irving Laurie Foundation Art Stairway space. The exhibition and catalogue are additionally supported by generous grants from the Karma Foundation and the following Exhibition Angels: Anonymous, Dorothea and Peter Frank, Gregg Seibert, and Judith and William Turner. Museum Trustees Herb Klein and Adrian Shelby made other important contributions to the success of this project.

The many loans from the Roy Lichtenstein Foundation and Estate were essential to the project. We also thank Maryellen Buckley, Nina Hope, Julian Solotorovsky, Peter Solotorovsky, Emilie Lapham, and the family of Hoyt L. Sherman, Lee Turner, P.A. and anonymous lenders for their generosity in parting with works for Montclair and the tour. Furthermore, the Roy Lichtenstein Foundation provided a generous grant to support the publication of this catalogue.

In addition to Dorothy Lichtenstein, President, and Jack Cowart, Executive Director, Roy Lichtenstein Foundation and Advisor to the Estate of Roy Lichtenstein, other staff of the Roy Lichtenstein Foundation, assisted with the myriad details and needs of this project. We are deeply grateful to Natasha Sigmund, Registrar, Roy Lichtenstein Foundation for loan coordination. Justine D. Price, part-time researcher for the Roy Lichtenstein Foundation catalogue raisonné provided critical information on 19th-century American art sources for the Lichtenstein works of the 1950s, connections with the work of Picasso, and a bibliography of American Indian art books in the artist's library now housed in the Lichtenstein Foundation, as well as her discovery of a 1979 BBC video featuring the artist painting one of the works from his Amerindian series. Avis Berman, Director of the Roy Lichtenstein Foundation Oral History Project, offered scholarly advice, contact information and the oral histories of friends and colleagues of Lichtenstein during the 1950s. We would also like to acknowledge the help of Shelley Lee, Intellectual Property Rights Manager, Estate of Roy Lichtenstein; Cassandra Lozano, Managing Director, Roy Lichtenstein Foundation and Administrator to the Estate of Roy Lichtenstein; Clare Bell, Foundation Researcher, catalogue raisonné, and manager for archival photography; Bettina Utz, Digital Imagery Processing; and Angela Ferguson, Foundation Staff Assistant and Assistant Registrar.

Many MAM Staff contributed to the success of this project,

including Renée Powley, Registrar in charge of coordinating all details of packing and shipping to MAM and the exhibition's four venues; Joe Zadroga and Jason Van Yperen for their exhibition design and installation; Heather Stivison and Aran Roche for securing funding for the show; Maryanna Robertson, Museum volunteer for compiling the photography credits; Anne-Marie Nolin and Toni Liquori for editing and coordinating the catalogue production and publicity; Susanna Sabolcsi, former Librarian and Jeffrey Guerrier, Librarian, Pia Cooperman, Public Programs Coordinator; and Mira Shin, research volunteer; Erika Namaka, curatorial assistant; and Christine Wahlia, intern.

We are thrilled this show will travel to four other venues and thank our listed colleagues for their participation in this project. At the Museum of Fine Arts, Santa Fe: Marsha C. Bol, Director; Laura Addison, Curator of Contemporary Art; and Timothy Rodgers, Chief Curator. Tacoma Art Museum: Stephanie Stebich, Director and Patricia McDonnell, Chief Curator. The Parrish Art Museum: Trudy C. Kramer, Director and Alicia Longwell, Lewis B. and Dorothy Cullman Chief Curator. The Eiteljorg Museum of American Indians and Western Art: John Vanausdall, Director and Jennifer McNutt, Curator of Contemporary Art.

Many friends, associates, and contemporaries of Roy Lichtenstein shared their memories and observations: Richard Anuskiewicz, Will Barnet, Tony Berlant, Sidney Chafetz, Chuck Csuri, Tom Doyle; Ruth Fine, Kathy Goodman, Jonathan Holstein, Ivan Karp, Olivia Motch, Joseph O'Sickey, James de Pasquale, Roy Harvey Pearce, Phyllis Sloane, Robert Rosenblum, Stanley Twardowicz, Ken Tyler, and Diane Waldman. Professional colleagues provided very helpful infor-

mation and research: Marisa Bourgoin, Archivist, Corcoran Gallery of Art; Leslie Cade, Archivist, The Cleveland Museum of Art; Carole Camillo, Cleveland Museum of Natural History; Mark Cole, Curator of American Art, Columbus Museum of Art; Becky Davis and Pat McCormick, The Butler Institute of American Art; Sarah Erwin, Collection Manager, Gilcrease Museum; Seth Hopkins, Executive Director, Booth Western Art Museum; Bertha L. Ihnat, Manuscripts Assistant, The Ohio State University Archives; Pam Koob, Curator, The Art Students League of New York; Claudia Defendi and Neil Printz, The Andy Warhol Foundation for the Visual Arts; and Cristine C. Rom, Library Director, Gund Library, Cleveland Institute of Art; Celia Skeeles, Librarian, the Amerind Foundation, Dragoon, Arizona; Abram Stavitsky for research in Cleveland; Carolyn Thum, Associate Registrar, The Cleveland Museum of Art; Diana Turco, Leo Castelli Gallery, New York; and Sabrina Miranda, Cleveland Public Library.

This was an exhibition and publication that required a great amount of assistance to accomplish. It celebrates a talent with a tantalizing New Jersey connection, for it was in this state while teaching at Rutgers University that Lichtenstein vaulted from the 1950s works, seen publicly in greater depth in this exhibition than ever before, to the Pop imagery on which his enormous reputation rests. We are, therefore, especially grateful to Leslie Mitchner and Suzanne Kellam of Rutgers University Press for assisting us with distribution. It is the purpose of museums to let us see art in fresh ways that contribute to scholarship and visual delight. We are proud this show does both and are deeply thankful to the many individuals and entities acknowledged above for making this project possible.

Patterson Sims
Director
Montclair Art Museum

Preface

The Roy Lichtenstein Foundation, now in its sixth year of operation, facilitates the public's access to, and understanding of, the life work of Roy Lichtenstein. At our offices in the artist's last studio in West Greenwich Village we have established, constantly expand, and maintain a comprehensive *oeuvre* archive, biography, chronology, bibliography, an oral history program, a reference library, various photographic and informational databases, a complex public website and an international catalogue raisonné research project. By our general enthusiasm and provocative data resources we hope to "plant seeds" of interest, themes, and ideas for exhibitions, publications, and other projects.

We see the Montclair Art Museum catalogue and exhibition as exhilarating and successful proof of our core belief that there remain many areas of Roy Lichtenstein's work that could, must, and will benefit from in-depth study and independent comparative analysis. We take an interpretively neutral position, correcting only for facts and data. We do not inhibit scholarship or analysis and we have a high tolerance for both learning on the job and for cross-cultural experience.

The Montclair project unofficially began several years ago when our friend, the Museum's then newly appointed director, Patterson Sims, asked if we could lend a Lichtenstein work. As part of the institutional credentials he mentioned the Museum's important tribal art collections. He did not know that the Foundation has been actively discovering and documenting many of the artist's 1950s American Indian works. We offered a subversive and expansive alternative: a curatorial and scholarly research exhibition, with hoped-for beauty and critical interest. To Montclair's credit, the challenge was accepted and we now read with glee and profound satisfaction the insightful essay by Gail Stavitsky and Twig Johnson. We are delighted with the evolution of our little idea that has become, in its maturity, a larger, wonderful and important publication, exhibition and national tour.

Knowledge and understanding of any artist's work and contextual historical and cultural position can only be cumulative. It doesn't happen all at once nor does it emerge from only one source or central authority. The Roy Lichtenstein Foundation encourages, and will continue to encourage, focused exhibitions by new scholars and critics as the basis for a more comprehensive and balanced interpretation of Roy Lichtenstein's five decade-long art career. This artist's most famous Pop ("cartoon") paintings from 1961 to 1965 don't make it easy or socially/financially convenient for museums stuck in the public "show-biz" rut. It takes vision, daring and an entrepreneurial spirit to go outside this classic 1960s conceit. We congratulate all at the Montclair Art Museum for taking this leap of faith. We knew that Montclair's rigorous and resourceful scholarship would help/force us all to learn new things about Roy Lichtenstein. It has been a fun and rewarding partnership and we feel new avenues of understanding and appreciation have been established.

We gratefully acknowledge the other lenders to this exhibition and the participating museums and staffs. Their support and involvement have been critical to expanding and sharing this heartfelt project with many new audiences in four major national cultural regions. We can only hope that through their various local symposia, lectures, publicity and tours, others will be stimulated to ask even more questions about Roy Lichtenstein and the art and artists of the second half of the twentieth century.

Jack Cowart
Executive Director
Roy Lichtenstein Foundation

*Roy Lichtenstein
in his studio,
1979*

LENORE SEROKA

Roy Lichtenstein: American Indian Encounters

by Gail Stavitsky and Twig Johnson

I take a cliché and try to organize its forms to make it monumental.[1]

What I'm trying to do is to make unity....despite any apparent humor I am trying to make a serious, immutable icon.[2]

...the way I looked at things was the same then as it is now—some kind of point of view about 'official painting'.[3]

I have always had this interest in a purely American mythological [subject] matter.[4]

As one of the founders of American Pop art, Roy Lichtenstein achieved an international prominence in the 1960s for his sly, provocative transformations of images from comics, cartoons, and advertisements, elevated to the realm of high art. Nevertheless, although Lichtenstein's work has been prodigiously exhibited and published, certain aspects of his inventive, prolific *oeuvre* have yet to be thoroughly examined. Among these relatively unknown bodies of work are the artist's pre-Pop adaptations of American history frontier themes in the 1950s and his "Amerindian" series of 1979-81. The artist's reticence in discussing his personal history has contributed, in part, to the lack of extensive, first-hand information on this work. In his groundbreaking study of Lichtenstein's early work published in 1988, Ernst Busche observed that both the artist and his dealer Leo Castelli were "more than a little responsible for the fact that our knowledge...is so incomplete" because of their conviction "that only the Pop work represents the 'real' Lichtenstein."[5] Seldom presented to the public, these early works were relegated to a past Lichtenstein generally preferred not to discuss. Furthermore, Busche has noted that the artist was mostly not able or willing to answer questions about specific dates, titles, or source images.

Nevertheless, Lichtenstein wholeheartedly supported Busche's doctoral research and upon several occasions commented on the links between his earlier and later bodies of work, most notably in an 1985 interview with Brenda Schmahmann who devoted part of a chapter of her dissertation to the "Amerindian" series. Like Busche, she found that the artist did not recall specific source images.[6] Although it poses challenges for the art historian, this tendency of forgetfulness is most likely due to Lichtenstein's focus on the present and the thorough assimilation of his sources into unified works of art. Having established his practice of utilizing stereotypical reproductions of America's history in the 1950s, Lichtenstein continued to explore the visual clichés by which American culture—high and low—has defined itself. Overlapping with his Surrealist series (1977-79), the surprisingly unknown Amerindian group has been mostly noted in passing as part of the artist's Lichtensteinian adaptations of art historical movements that characterized his output of the 1970s. In both the earlier and later works, Lichtenstein's encounters with the theme of the American Indian as a vital mythic component of our country's heritage was treated with his characteristically irreverent wit, gentle humor, and affectionate irony. Exploring what he called "a kind of conception of the over-reproduced," Lichtenstein reworked images of American Indians and their cultures as the clichéd signs of high art and popular culture/mass media in a fresh, modern way, exposing the schema or abstract structure underlying these means of representation.[7]

Early Years

Part of the foundation for Lichtenstein's appropriations of American Indian themes and motifs was laid during his childhood. Growing up on the Upper West side of Manhattan, Lichtenstein attended the Franklin School for Boys, a private academy on West 89th Street off Central Park West, from 1936 to 1940. His proximity to the Amer-

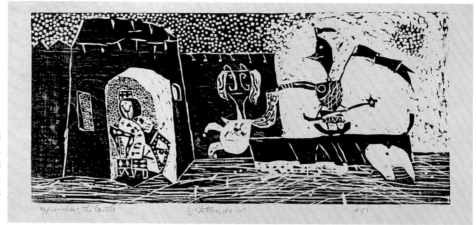

Fig. 1 Roy Lichtenstein
Approaching the Castle, 1951
Woodcut on various drawing papers
10 1/8 x 18 15/16 in. (variable)
Publisher: The artist

ican Museum of Natural History during his teenage years was significant. Lichtenstein spent a lot of time there on his own, exploring the section dedicated to the origins of man and most likely looking at the halls dedicated to the traditional cultures of the Americas. Among the areas that likely provided visual stimulation was the museum's oldest exhibition space, the Hall of Northwest Coast Indians.[8] Although not "a great interest," the American Indians were, in Lichtenstein's words," always something," evidently an outgrowth of his early interests in anthropology and natural sciences.[9] He also enjoyed listening to *The Shadow, Flash Gordon* and *Buck Rogers* on the radio, which may have (unconsciously) contributed to his later interests in heroic and mythic clichés.[10]

Having drawn a lot as a child, Lichtenstein took outside art instruction as a teenager because no courses were available at his school. Following his graduation in 1940, Lichtenstein enrolled in the Art Students League where he briefly studied with Reginald Marsh (1898-1954), an exponent of realism and regionalism whom Lichtenstein knew about from the first art book he received, Thomas Craven's *Modern Art.* (1934). Mostly disappointed with Marsh's instruction which emphasized realist painting technique rather than developing a personal style, Lichtenstein proceeded with his plans to see more of the country, choosing to study art at Ohio State University in Columbus. Later observing that he "had no idea what art was then," Lichtenstein's artistic horizons were considerably broadened at Ohio State through his contact with Hoyt L. Sherman (1903-1981), a Professor of Fine Arts and champion of modernism.[11]

As Lichtenstein's most important influence during his student years in the 1940s, Sherman encouraged his pupil to appreciate the work of Cézanne, van Gogh, Gauguin, Matisse, Mondrian, and Picasso. Encouraging the development of an individual approach, Sherman also emphasized Gestalt-influenced theories of organized

visual perception in his rigorous, innovative drawing course that had a lifelong influence upon Lichtenstein. Sherman's concept of "perceptual unity," defined by Lichtenstein as "a way of building a unified pattern of seeing," was especially important for achieving the desired unification of forms in a work of art.[12] In his writings, especially *Drawing by Seeing* (1947) and *Cézanne and Visual Form* (1952) and presumably his teaching as well, Sherman demonstrated how abstract art was the logical culmination of the need to transform three-dimensional reality into a unified, artificial two-dimensional realm (the "field structure"). Using reproductions, he referred to specific examples in modern art, including "the pictorial projection of a particular FEELING point of view, evidenced...in the "irony" of Klee and the "nonsense" of Miró," both of whom would soon, along with Picasso, become key influences upon Lichtenstein's early work.[13]

Lichtenstein's studies with Sherman were supplemented by lectures in art history covering all of Western art since the earliest cave paintings. His textbook for these courses was likely the copy of Elizabeth Gardner's *Art Through the Ages* (1936), preserved in the Lichtenstein Foundation library that is signed and inscribed with his Columbus address. In addition to chapters on historical and modern European and American art, Gardner wrote about "the art of the American Indian" and reproduced examples of Northwest Coast art from the American Museum of Natural History that Lichtenstein likely would have already seen. Lichtenstein seems to have especially paid attention to the section on Picasso since two images of his work have actually been cut out of the book, perhaps to adorn the artist's studio wall.[14]

Picasso was also on Lichtenstein's mind when the young artist attempted unsuccessfully to visit him in Paris after World War II. Like other American soldiers, Lichtenstein went to Paris late in 1945 in an army program

to study French language and culture, however, his sojourn was soon interrupted by the need to return to New York when his father became deathly ill. Discharged from the army, Lichtenstein resumed his studies with Sherman, graduating with a B.F.A. in 1946 and then continued, earning a Master's degree in Fine Arts in 1949. He worked as an Instructor in Fine Arts at Ohio State University from 1946 until 1951, when his contract was not renewed. Lichtenstein's Master's thesis conveys his artistic commitment to modernism, as suggested by the following excerpts that were provided by him as a Whitmanesque poetic "general expression of my feelings about painting":

> Art is mysterious, but definable.
> It is mysterious as a thing,
> But definable as a way....
> In awe, then, you must sing
> An Ode to the Wonderful Wizards of Art:
> Sing of Klee's secret glee,
> And of Picasso's electric expression,
> ...And sing of stolid Cézanne,
> And praise the mad Van Gogh,
> And sing of Gauguin's magic,
> Though you'd rather be bewitched by Rousseau.
>Look at that Matisse!
> Open your eyes wide!
>You must act as Cézanne
>And not just to understand Cézanne
> You're looking for the painters' common action,
> Through which they know each other,
> And through which they achieve art.[15]

Lichtenstein illustrated his thesis with a selection of paintings, pastels, and drawings created within the previous year. He had also extended his modernist experimentation into the realms of printmaking and sculpture

as well with his first examples of these mediums in 1948. The works of Picasso, Braque, Miró, Kandinsky, Klee, and Mondrian form the stylistic basis for Lichtenstein's subsequent series in various mediums, begun in 1950, which is populated with brave medieval knights, maidens being courted, slain dragons, tournaments, castles under siege, and abductions. (*Fig. 1*) Developing a flat, semi-abstract style inspired by Synthetic Cubism and Constructivism, Lichtenstein was attracted to the motifs and non-illusionistic style of the medieval *Bayeaux Tapestry*, as well as Picasso's *Guernica* (1937, Museo Nacional Centro de Arte Reina Sofia) and his print *Minotauromachy* (1935). Klee's playful, seemingly naïve, childlike schematization of figurative elements also inspired Lichtenstein's caricature-like interpretations of his formalized, romantic subjects. (*Fig. 2*) Presented as "formulaic expressions of pathos," the knighthood series laid the foundation for a whimsical sense of irony and parody that pervades Lichtenstein's oeuvre.[16] Furthermore, Lichtenstein's humorous embrace of these archetypal subjects, based upon the myth of the hero, sets the stage for his first mature body of work begun in 1950-1951, what we will call the Americana series, a term first introduced by Busche (as the title of the fourth chapter of his book).

The Americana series, 1951-1956

Overlapping with the last works in the medieval series, Lichtenstein became involved with the theme of the "American knight"—the cowboy and pioneers of America's frontier West, as well as their tragic counterparts, the displaced American Indians.[17] Although Lichtenstein's preoccupation with myth and the romanticized hero has been attributed in part to his growing awareness of developments in Abstract Expressionism, it seems more likely that his friendship with a colleague at Ohio State University played a greater, more immediate role.

Around 1949, Lichtenstein met Roy Harvey Pearce, Associate Professor of English, through a mutual friend. Pearce taught

Fig. 2 Paul Klee
Arrival of the Jugglers, 1926
6 7/8 x 10 3/4 in.
Oil on incused putty on cardboard
mounted on cardboard
Acquired 1939, The Phillips Collection,
Washington, DC
©2005 Artists Rights Society (ARS),
New York, VG Bild-Kunst, Bonn

EDWARD OWEN

American literature and was working on a book based upon his dissertation; it was published in 1953 with the title *The Savages of America: A Study of the Indian and the Idea of Civilization.* While Pearce does not know if Lichtenstein read his book, he has recalled that he had a book of the 19th-century American artist George Catlin's work in his home that was borrowed by Lichtenstein:

> I had in the house, or I borrowed from the library, one of the many volumes by George Catlin...These painters... were sent out with all the expeditions beginning with Lewis and Clark, the way they send out photographers now. Catlin was one of the first and he was widely published. Roy saw the book and borrowed it and never commented or anything, except he began painting these Indian paintings.
>
> I'm sure he got other things from the library to look at, but the Catlin drawing was the one he saw at our house....

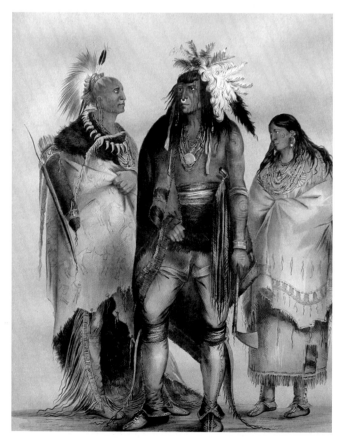

Cat. No. 39. George Catlin (1796-1872)
North American Indian Portfolio
Group of Native American Indians from Life, 1845
Hand colored lithograph
23 1/2 x 18 1/2 inches
Montclair Art Museum, Gift of Ruth Bannister in memory of Lemuel Bannister, 1981.23.1

> That was the start of his move from medieval to Indian things.[18]

Pearce also recalled having "at least one book with a lot of different painters of Indians. Roy saw that, too."[19] Referring to these 19th-century American history paintings of the West as "genre pieces," Pearce observed:

> I remember one thing he said about the Indians and the genre pieces. He said, 'These things were never painted. I'm painting them for the first time.... I think he...thought they had too much photographic realism and not enough painterly activity shown in them.[20]

Lichtenstein's objection to the photographic journalism of these earlier works seems to coincide with his modernist rejection of the provinciality of Regionalism, his quest for an individual identity, and his growing fascination with the clichéd or what he would later call the "discredited" subjects of American culture.[21] Indeed Pearce's book addressed the key stereotypical aspects of how Indians were portrayed in literature and the visual arts during the 19th century. He observed how the writings of travelers to the West established the misconception that, despite a variety of separate cultures, "the Indian is everywhere essentially the same."[22] The predominant hunting culture of the Plains Indian became the standard of "savagism" and justification for the encroachment of the "civilized" agrarian frontiersmen. Furthermore, the stereotype of Indians as wild, primitive, polytheistic nomads lacking a sense of private property and settled government, and as invaders, permeates the literature reviewed by Pearce. A corollary concept of the noble savage appears in Pearce's discussion of Catlin's monumental book *Letters and Notes on the Manners, Customs, and Condition of the North American Indians* (1841) that refers to "[the Indian] man in the artless and innocent simplicity of nature."[23] It is possible that Lichtenstein borrowed from Pearce a later edition of this copiously illustrated Catlin book that was reprinted many times. Furthermore, illustrated articles on Catlin were appearing in *Art News* and other periodicals during the late 1940s and early 1950s.[24] In 1943 a major exhibition at the Museum of Modern Art, *Romantic Painting in America*, featured the work of Catlin and western scenes by Albert Bierstadt, Currier & Ives, Alfred Jacob Miller, and Frederic Remington as "less studied and less well understood than European art."[25]

George Catlin (1796-1872) was the first significant American artist to devote himself to the study of the American Indian as "the living monuments of a noble race" who had been subjected to "their rights invaded, their

morals corrupted, their lands wrested from them, their customs changed, and therefore lost to the world."[26] During the 1830s, he completed at least five trips west, producing hundreds of portrait and landscape paintings, which he began to exhibit as a group of works known as Catlin's Indian Gallery in 1837, representative of many different tribes that he visited. Despite his significance, however, Catlin's work was mostly disregarded by art historians even at mid-century, as observed by Bernard De Voto, whose well illustrated volume *Across the Wide Missouri* (1947) was one of the first to critically analyze his work. De Voto observed that Catlin's aforementioned book of letters (1841) was complemented by his album of lithographs, *Catlin's North American Indian Portfolio* (1844) that supplemented the Indian Gallery "in establishing the first set of conventions of Western painting."[27] (*Cat. Nos. 39-43*). De Voto's discussions and reproductions of subsequent painters of the West, especially Alfred Jacob Miller and Karl Bodmer, were also important as potential sources of information for Lichtenstein. During the early decades of the twentieth century, Western art had largely fallen into critical disfavor, virtually ignored by art historians because of its air of nostalgic provincialism.[28] Nevertheless, the early twentieth century had ushered in "a 'Golden Age' for the pop culture West....[as] N.C. Wyeth, Howard Pyle, and countless other illustrators gave an entire generation their first view of cowboys and Indians in the pages of dime novels and adventure magazines" as well as early films.[29] Interest in Western subjects grew on the part of anthropologists, ethnologists, writers, and historians, including Lloyd Haberly who wrote a biography of Catlin in 1948 and De Voto himself, a writer for *Harper's Magazine*. De Voto's call for art historical studies of Catlin, Bodmer, Miller, and others probing beyond the ethnographic accuracy of their subject matter was unheeded for many years. As late as 1953, the basic research on artists of western imagery remained to be done, with few exceptions such as Harold McCracken's *Portrait of the Old West* (1952) and his survey of Frederic Remington (1947), as well as Robert Taft's *Artists and Illustrators of the Old West 1850-1900* (1953).[30] According to Busche, the illusion of these works serving as eyewitness accounts within a clichéd format of history painting is what fascinated Lichtenstein—"the difference between real life, between the actual event and what became of it in the medium of art."[31]

It is thus intriguing that Lichtenstein chose to focus upon images of western Americana which were still largely overlooked even during an era following upon the nationalistic heels of Regionalism. During the 1930s,

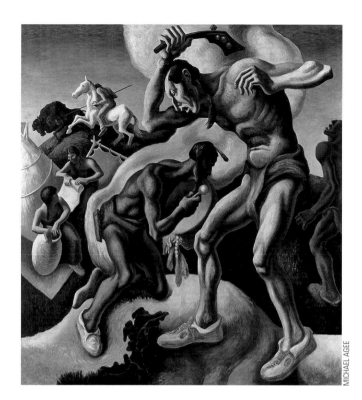

MICHAEL AGEE

Fig. 3 Thomas Hart Benton
The Arts of Life in America: Indian Arts, 1932
Tempera with oil glaze on linen,
mounted on panel, 93 x 84 in.
New Britain Museum of American Art
Harriet Russell Stanley Fund 1953.19

themes of western American history and depictions of Native Americans were particularly prevalent in depression era Federal art projects, especially Post Office murals, as illustrated in the book *Art in Federal Buildings/Mural Designs 1934-1936* (1936), preserved in Lichtenstein's library.[32] Furthermore, leading regionalist Thomas Hart Benton had achieved prominence for his widely reproduced mural paintings, several of which incorporated fabricated, romanticized Native American historical themes, such as *The Arts of Life in America* that included the "Indian Arts—Dancing, Chasing the 'Great Spirit,' Basket Weaving, Preparation of Skins, Hunting [Buffalo]." (*Fig. 3*) Benton continued his realist depictions of these themes even in the 1950s when he wrote about the demise of Regionalism.[33] Lichtenstein was well aware of regionalism as what he called "the pervading style in the Midwest.... And we didn't like regionalism or any of that at all."[34]

One of the images from Benton's *The Arts of Life* series was reproduced in Gardner's textbook owned by Lichtenstein. It is therefore tempting to speculate that Gardner's comments on 19th-century American art, in particular, as examples of the young country's "provincial mediocrity" had an impact on Lichtenstein.[35] Indeed it is this "discredited" aspect of American art that seems to have

Fig. 4 John Vanderlyn
The Murder of Jane McCrea, 1803-1804
Oil on canvas
32 x 26.5 in.
Wadsworth Atheneum Museum of Art,
Hartford, Connecticut
Purchased by Subscription, 1855.4

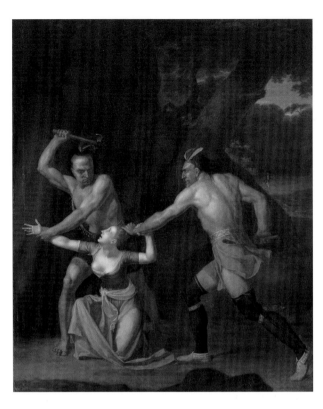

attracted him and afford-
ed the opportunity to
attempt original mod-
ernist restatements of
these themes that he
later called "humorous
variations." [36] His close
friend at this time and
fellow artist Joe O'Sickey
has observed that Lich-
enstein was "looking for
something to make his
own, a subject to put
shapes to...having fun
with history books" as he
"looked at old western
paintings and paraphrased them, taking all the senti-
mentality out of them." [37] Sidney Chafetz, a colleague at
Ohio State University, has recalled that his witty, sophis-
ticated friend "would see the contemporary possibilities
in a 19th-century work that was considered passé, the
possibilities for recreating images where the rest of us
just saw the image...he thought there was something
humorous in the innocence of the representation." [38] As
Roy Harvey Pearce has recently recalled Lichtenstein say-
ing, his 19th-century forebears "didn't really paint them.
I am painting them for the first time." [39] Lichtenstein's
later comments about his work shed light on the possi-
ble meaning of his assertion:

> I'm using their work, but I'm redoing it in my own
> way, expecting it to make reference to the original. [40]

Although his comments were made in the context of a
discussion of his later appropriations of Picasso,
Matisse, and various art movements, they are relevant
for an understanding of Lichtenstein's early works as
well. Indeed the artist later observed in an article pub-
lished in 1993, "it's amazing how much those historical
pictures I was doing in the mid-fifties look like the ones
I'm doing now." [41] He also stated that he was "making a
comment on other people's graphic work, which I'm still
doing...and it was ironic, although not ironic enough, I
guess." [42] His depictions of cowboys and Indians were
"historical things":

*I was taking the kind of
stodgy pictures you see
in history textbooks and
redoing them in a modern-
art way.* [43]

*I know I had a feeling
about official painting,
or any painting that
was historical or
archaeological or mon-
umental. I still do. It's
their reliance on great
subjects for their force
that interests
me....there was some-
thing humorous in the
rearrangement of tired
themes.* [44]

Lichtenstein's ambition
recalls that of Larry
Rivers whose renowned,
deadpan parody of
Emanuel Gottlieb
Leutze's *Washington Crossing the Delaware* (1851, The
Metropolitan Museum of Art) was first exhibited at the
Tibor de Nagy Gallery in December 1953. In the fall of
1951 Rivers had exhibited his expressionistic painting
The Burial (1951, The Fort Wayne Museum of Art), based
on Courbet's masterpiece that he had seen at the Louvre.
Disenchanted with the nonobjective orientation of the
New York School, Rivers wanted "to do something that
no one in the New York art world could doubt was dis-
gusting, dead and absurd. So what could be dopier than
a painting dedicated to a national cliché—Washington
crossing the Delaware." [45] Lichtenstein had painted two
even earlier adaptations (ca. 1951, Roy Lichtenstein
Foundation and present location unknown) of Leutze's
widely reproduced, monumental history painting, among
the first works in his Americana series. [46] Painted on the
hundredth anniversary of Leutze's salon classic, Lichten-
stein's slightly ironic, Cubist adaptation was not, howev-
er, exhibited in the 1950s and therefore did not receive
the notorious attention of Rivers' more sketchlike,
painterly version. This work established Rivers' reputation
as a heretical challenger of the status quo of Abstract
Expressionism at a time when the Cold War, the anti-
communist campaign of Joe McCarthy, and the election
of Eisenhower had placed the issue of patriotism upper-
most in many Americans' minds—perhaps that of Licht-
enstein to some degree as well. Only much later would

Lichtenstein's version be recognized "with its simplified, naïve style and comical representation of a nobelized [sic] event" which recreated "familiar cliché images in a light-hearted manner."[47]

Evidently attracted to the perceived incompatibility of clichéd, nostalgic Western subjects with high art, Lichtenstein primarily focused upon his adaptations of American history scenes in a Cubist idiom from the years 1951 to 1956. As observed by Ernst Busche in his landmark study of Lichtenstein's early years, these works can be divided into three groups: "the political history of the emerging...nation, the frontier with typical figures from Western legend, and third, associated with the frontier but distinct in content,...Native Americans."[48] At this time, Lichtenstein resided in Cleveland, Ohio where his first wife Isabel, an interior designer, was an assistant in the non-profit Ten-Thirty Gallery where his work had been exhibited in 1949. Working in a variety of commercial art-related positions, Lichtenstein traveled frequently to New York where he perhaps was aware of Rivers' work and had his first New York one-man show in 1951 at the Carlebach Gallery. This exhibition (which took place shortly before his move to Cleveland) was followed at the end of the year by another one-man show at the John Heller Gallery. Lichtenstein later commented that his residence in Ohio likely influenced his tendency to work from reproductions:

> We weren't in very close contact with current painting and sculpture. Most of what we saw was in reproduction. Reproduction was really the subject of my work.[49]

The brief reviews that accompanied Lichtenstein's exhibitions provide a critical framework for examining his series based on American frontier themes. The John Heller exhibition evidently provided the first extensive opportunity to view these works. The checklist which included previous medieval-themed works (including a self-portrait as a knight), was accompanied by an essay by Hoyt Sherman who observed that the artist's "irony has been effectively structured in terms of configuration—the painter's language."[50] Lichtenstein's ironic approach was characterized by another reviewer as "a manner of parody entertaining to see in a wide gamut of folklore themes which the artist relishes particularly."[51] His "extensive

acquaintance with Paul Klee,...Mexican-Indian art, icons, and...Coptic art" was noted by another critic who was particularly impressed with the "first-rate *Death of Jane McCrea*" (1951, Cat. No.5).[52] In this "more complex (and successful)" work, "all elements are interlocked, in the cubist manner, and figures become part of a spacious, asymmetric quilt" in "strong earth colors, handling combinations of red and brown especially well."[53]

The Death of Jane McCrea is Lichtenstein's recreation of a once renowned painting, *The Murder of Jane McCrea* (Fig. 4) by the Neoclassical master John Vanderlyn (1776-1852), derided by Gardner in her textbook as a painter of "technically proficient artificial canvases for which there was no demand."[54] Created in 1804, this painting was originally commissioned as an illustration for Joel Barlow's poem, the *Columbiad*, which was based on the actual murder of Jane McCrea who was scalped by Indians as she was traveling north in her wedding dress towards Fort Edward, New York in 1777 to meet her fiancé advancing with the British army. McCrea's massacre soon became propagandized to dissuade Tory sympathizers and promote the revolutionary cause. Its caricatural emphasis upon the brutality and greed of the Indians who would subsequently bring McCrea's scalp to the English camp for a reward was highlighted in a *Life* magazine article of July 3, 1950 that may have served as Lichtenstein's source. This work was reproduced in an article on the American Revolution with the following caption:

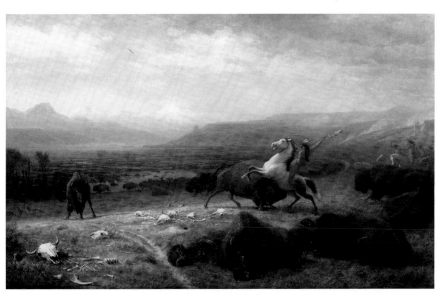

Fig. 5 Albert Bierstadt
Last of the Buffalo, ca.1888
Oil on canvas
60 1/4 x 96 1/2 in.
Buffalo Bill Historical Center, Cody, Wyoming
Gertrude Vanderbilt Trust Fund Purchase 2.60

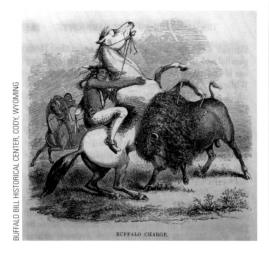

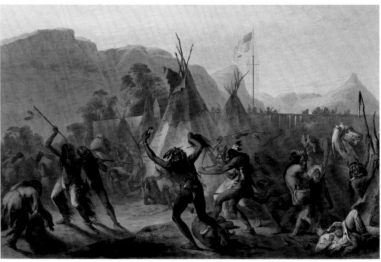

Fig. 6 Albert Bierstadt
Buffalo Charge, 1870
Illustration for Fitz Hugh Ludlow's
The Heart of the Continent (1870)
Courtesy of Peter H. Hassrick

Fig. 7 Karl Bodmer
Attack on Fort MacKenzie, August 28,1833, 1840-43
Hand-colored aquatint
Published in *Voyage dans l'intérieur de l'Amérique du Nord,...1832, 1833 et 1834,
par le prince Maximilien de Wied-Neuwied.* (published 1840-1843. Tab.42)
Rare Books Division, The New York Public Library,
Astor, Lenox and Tilden Foundations

*Indian atrocities were common on the frontier—the
British hired savages to terrorize Americans...This is
the killing of Jane McCrea near Fort Edward. Miss
McCrea was pro-British, but the Indians, sometimes
paid on a bounty basis, killed her anyway.*[55]

Other possible sources for Lichtenstein might have been
a reproduction of Nathaniel Currier's 1846 lithograph *The
Murder of Miss Jane McCrea A.D. 1777* (with a frontal view
of McCrea's face that corresponds to Lichtenstein's doll-
like protagonist) and an article in the Fall 1949 issue of
Art Quarterly which reproduced engraved versions of
Vanderlyn's work. The author of this article observed that
since the 1850s "Vanderlyn's influence gradually disap-
peared [and] inspired no popular imitative efforts but
the painting remains as a not unworthy historic example
of American realism invading the grand style."[56]

Despite the drama of this subject, Lichtenstein has
retained the classic coolness and relief arrangement of
Vanderlyn's work. Nevertheless, he has completely recast
and modernized the subject in Synthetic Cubist terms,
retaining only caricatural vestiges which identify the
two attacking Indians: the feathered headdress on the
lower Indian, perhaps a quiver with arrows above
McCrea's head, and a possible borrowing of an Indian
roach (*Cat. No. 52*) or Mohawk-like hairstyle on the
upper Indian image, which may also be a shield with a
portrait design, surrounded by feathers. This stereotypi-
cal rendition of these Indians as Mohawks (as they are

identified in the *Columbiad*) rather than their actual
identities as Algonquin or Iroquois typifies the long-
standing tradition of "most nineteenth century Indian
depictions [which] portray the plains tribes that seemed
most closely to approximate the European myth of
the...hunter-savage."[57]

Lichtenstein's flattened, schematized translation of his
subject into a geometric, Cubist framework has been
compared by Busche to the early frontier painters "who
perceived types in the foreign Indian faces rather than
specific personalities."[58] Lichtenstein's formalization and
abstraction thus served his desire to examine the for-
mulaic, archetypal representations and visual clichés of
his pre-existing subject matter.

The caricatural, childlike approach to the distorted,
oddly proportioned figures, rooted in his appreciation of
Klee and Picasso, was common to other works of 1951-
1952 in this series, including *The Last of the Buffalo II*
(1952, *Cat. No.6*).[59]

Existing in two versions, one of which was shown in
the Heller exhibition, these works are based on paint-
ings by Albert Bierstadt (1830-1902) with the same
title. In 1888 Bierstadt painted the monumental *Last of
the Buffalo* (*Fig. 5*) which hung in the Paris Salon but was
rejected for the 1889 Paris Exposition because it was
considered "out of keeping with the developing French
influence in American painting."[60] Expressing his pro-

found sense of rejection with this news, Bierstadt proclaimed, "I have endeavored to show the buffalo in all his aspects and depict the cruel slaughter of a noble animal now almost extinct."[61] A frequent theme in the work of Catlin, Charles F. Wimar, and others, the buffalo hunt has been interpreted as an allegory of the vanishing Indian, prominently featured here thrusting a spear at a charging beast, amidst the already dead or wounded.[62] (*Cat. Nos. 40-43*) Bierstadt had frequently returned to this theme; an earlier rendition, entitled *Buffalo Charge* was reproduced in Fitz Hugh Ludlow's book *The Heart of the Continent* (1870). It bears a striking comparison to Lichtenstein's interpretation. (*Fig. 6*)

Rather than providing a panoramic view as in his painting of 1888, Bierstadt focuses upon an Indian on horseback locked in mortal combat with a buffalo. Lichtenstein also reduces the drama to the central duel, compressing the protagonists into a colorful patchwork of interlocking, geometric forms animated by schematic signs—feathers, spear, and shield. An almost peculiar sense of humor and whimsy animates this work and *The Death of Jane McCrea* that was recognized by the critic Carlyle Burrows in his reference to Lichtenstein's "manner of parody."[63]

A key related work of this period, not included in the Heller show, was *The Assiniboins Attacking a Blackfoot Village, 28 August 1833*, a study after Charles Bodmer (ca. 1951, *Cat. No. 7*). Originally from Switzerland, the painter Charles or Karl Bodmer (1809-1893) witnessed this surprise attack while accompanying the naturalist Prince Maximilian on a voyage up the Missouri River to Fort McKenzie, the American Fur Company's trading outpost among the Blackfeet. He memorialized this event in a widely reproduced painting (*Fig. 7*) illustrated in De Voto's *Across the Wide Missouri* (1947) as "a study of Indian war [that] has never been surpassed."[64] Bodmer's work emphasizes the dynamic action of the attacking Assiniboines—characterized by De Voto as "rowdy Indians of the Dakota stock...with a long record as bad actors" and the Blackfeet who fought back in their war regalia as "free-wheeling terrors of the West".[65] Lichtenstein, however, typically removes the drama and drains the emotional impact by schematizing the figures and reducing the action to Bodmer's central trio of warriors: one to the left firing his rifle, another with a bow and arrow, and a third wearing fringed leggings and a possible quiver on his back, brandishing a spear. Imaginative liberties are taken with the transformation of the archer into an upright dominant figure, and the intensification of the war paint on the face of the supine, coiled figure the bowman is forced to

step across. The background reflects the tipis and mountains of the original (to the left) and the green of the fort's palisade (to the right). Lichtenstein has carefully inscribed the source for his work on the picture itself.[66]

Another important related work of this period which was also not included in the John Heller show was *The End of the Trail* (1951, *Cat. Nos. 8, 9*), based on the well known sculpture by James Earle Fraser (1876-1953), designer of the buffalo/Indian head nickel first minted in 1913. In a later conversation with Ernst Busche, Lichtenstein recalled that *The End of the Trail* was "the first conscious cliché."[67] This popular, widely reproduced sculpture (*Fig. 8*) originally modeled in 1894 and existing in various cast versions, embodied the Romantic clichéd image of the noble, defeated Indian savage with lowered spear and hunched body, resigned to extinction.[68] Lichtenstein has translated the three-dimensional sculpture into the flat, two-dimensional realm of his painting and works on paper; presumably, the intermediary of reproductions

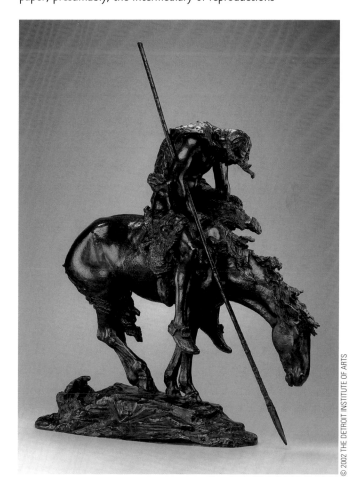

Fig. 8 James Earle Fraser
End of the Trail, 1918
45 x 30 x 9 in.
Bronze
Gift of George G. Booth, 19.66

aided this process.[69] He evidently used the different orientation of the sculpture in reproductions because the horse and figure are reversed in Cat. Nos. 8 and 9. In the painting, the horse's long neck forms an exaggerated curve that is offset by his full tail, as well as the Indian's dramatically striped face, pathetically stick-like arms and absurdly long spear. His feathered costume, painted warrior face, and posture of defeat are even more evident in the mixed media version. (Cat. No. 9)

The distortions of the horse's form and the overall Cubist inflection recall Picasso's *Guernica* (1937, Museo Reina Sofia) which Lichtenstein later recalled having seen, perhaps in Cleveland where it was on view late in 1940 as part of the exhibition *Picasso: Forty Years of His Art*. Lichtenstein retained a copy of the exhibition catalogue for his library. The Indian's mask-like face can be related to Picasso's *Les Desmoiselles D'Avignon* (1907, The Museum of Modern Art), also reproduced in this catalogue with other examples reflecting his "African period" and interest in primitivism.[70] Busche has also noted the impact of Paul Klee, whose striated, schematic renditions of figures were featured in a retrospective of 1945, for which Lichtenstein retained the exhibition catalogue.[71] (Fig. 2)

Although Lichtenstein later referred in various interviews to Klee, he acknowledged Picasso as the primary modernist influence in these works, asserting:

> *Picasso always had a great influence on me. When you think about Cubism, you think about Picasso and the range of his images: the African influence, the classical influence, even his ventures into Surrealism....My work of the '40s and '50s frankly looked like Picasso; it was too influenced by him. It seemed a heavy burden, something I wanted to get away from.... I felt freer [later] copying a Picasso than being burdened by his subtle influence.*[72]

Influenced as well by Picasso's earlier Blue and Rose periods, Lichtenstein seems to have had this body of work in mind when creating some of his earliest works on paper focusing on the theme of the American Indian. Although more expressionistic in feeling, the broadly brushed *Indians with Travois* (ca. 1951, Cat. No. 1), can generally be compared to such Rose period works as *Boy Leading Horse* (1905, The Museum of Modern Art) and *The Watering Hole* (1905 gouache study, Worcester Art Museum). The theme of the *travois* (hauling apparatus constructed by Plains Indians to move household goods and people) establishes the nomadic identity of the subject. The more classical, untitled study of Indians characteristically riding bareback on horses (ca. 1951, Cat. No. 2) bears even closer comparison.[73] The combination of predominantly linear, gracefully curved, upright and recumbent figures is also comparable to Picasso's drawings of bathers from 1918-1921, reproduced in Jean Cassou's *Picasso* (1949) in Lichtenstein's library.[74] Even the looseness of the renditions of the less specifically derivative *Untitled (Indian)* (1950, Cat. No. 3) and *Indian and Buffalo* (ca. 1951, Cat. No. 4), a possible study related to *The Last of the Buffalo* (Cat. No. 6), can be related to Picasso's drawings, such as an initial shorthand study for *Guernica* which was cut out of Lichtenstein's copy of *Picasso: Forty Years of His Art*.[75] The figure in *Untitled (Indian)* wears a feathered headdress, a parted, braided hairstyle, and seems to be holding a Plains Indian shield or feathered dance fan.

Although these works on paper cannot be easily linked to any specific 19th-century sources, they were likely informed by Catlin's linear engravings of American Indian subjects in his aforementioned book, *Letters and Notes*. *Indian with Travois* can be compared to the Indian families on horses pulling *travois* in *Crows on the March*, which was reproduced in the *Album of American His-*

Fig. 10 Will Barnet
Strange Birds, 1947
Lithograph
9 3/4 x 13 in.
The Montclair Art Museum, Museum purchase; Acquisition Fund, 1994.42

tory (1945) in Lichtenstein's library (*Cat. No. 37*).[76] Furthermore, the pictographic images of American Indians fighting, as recorded in a Catlin engraving of the robe of Mah-to-toh-pa, seems a likely source of inspiration (along with Picasso and Klee) for Lichtenstein's schematic figures burned into a wooden bowl (ca. 1951, *Cat. No. 10*).[77] This work has typical geometric lines and figures associated with Northwest Coast, Southwest, and Plains motifs. The four major figures are typical "Lichtenstein" Indians, complete with feather headdresses, shields, and, in two cases, holding arrows. Their embellishments, including fringed leggings, shirts, bows, arrows, feathers, shields, and face paint are all reminiscent of stereotypical Plains warriors. The fourth figure shows a notable southwestern Hopi influence, with a face very typical of katsinas. The star-like imagery on the face is characteristic of the Chasing Star or Meteor katsina. This figure also appears to wear a *manta*, a pueblo dress that is woven from cotton or wool. The smaller designs on the bowl are reminiscent of Northwest Coast design with a classic Northwest coast eye shape. In choosing to burn designs into a wooden bowl, Lichtenstein made reference to Northwest Coast and Eastern Woodland tribal arts. (*Cat. Nos. 49, 50*)

This unusual object and other works of the 1950s based on American Indian motifs raise the issue of Lichtenstein's possible interest in Native American art and culture at this time when the artist himself evidently carved a totem pole (location unknown), likely adapting the themes of Northwest Coast examples. Pearce has recalled that it was a "wooden structure, which he called *The Totem Pole*."[78] In the early 1960s, Lichtenstein had a crudely rendered tourist trading-post totem pole in his studio, lacking the interlocking, fluid lines, size, and motifs usually associated with Northwest coast totem poles.[79] (*Fig. 9*, see frontispiece)

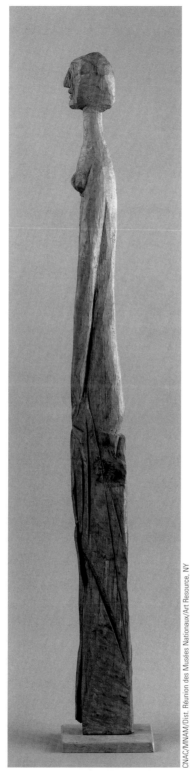

CNAC/MNAM/Dist. Réunion des Musées Nationaux/Art Resource, NY

Fig. 11 Pablo Picasso
Seated Woman, Autumn, 1930 MP272
Carved wood
22 x 1 x 2 1/2 in.
Musée Picasso, Paris, France
© 2005 Estate of Pablo Picasso/Artists Rights Society (ARS), New York

Lichtenstein's modernist adaptations of American Indian motifs were preceded by the efforts of a variety of American artists, including George L. K. Morris, co-founder of the American Abstract Artists, whose 1930s and early 40s Synthetic Cubist scenes of Indians fighting and hunting provide an intriguing, though likely unknown stylistic parallel.[80] The most immediate precedents could be found in the 1940s and early 50s works of such Abstract Expressionists as Adolph Gottlieb, Jackson Pollock, and Richard Pousette-Dart, as well as the Indian Space painters that included the progenitor of the style, Steve Wheeler, as well as Robert Barrell and Will Barnet (*Fig. 10*), among others.[81] Although Lichtenstein shared stylistic roots of Cubism and Surrealism with these artists, he did not share their spiritual, mythic engagement with Native American art as a vehicle for moving "beyond Cubism" towards what Barnet has called "a search for American values" independent of Europe.[82] Furthermore, as his friend and Ohio State University colleague Chuck Csuri has observed, "we did not talk about American artists; they were not considered important. There was no major American artist we could take seriously."[83]

In Cleveland, Lichtenstein could have seen examples of Native American art in the collections of the Cleveland Museum of Art and possibly the Cleveland Museum of Natural History.[84] The postwar years were fraught with a variety of changes for American Indians as federal services and protection were reduced or eliminated under the guise of assimilating them into mainstream American society.[85] Despite this situation which resulted

in the relocation of thousands from reservations to cities, a growing sense of tribalism and nationalism laid the foundation for the Red Power movement of the 1960s and 70s. Stereotypes in popular culture persisted, especially via Hollywood movies. The well known, grinning Chief Wahoo logo of the Cleveland Indians, experiencing a winning streak during Lichtenstein's time in Cleveland, was an example of this type of cliché.[86]

Although these phenomena provide an intriguing cultural backdrop, Lichtenstein had already established his mode of working primarily from magazine, print, and art book reproductions. Furthermore, as Busche has observed, "ultimately it was not the Indians themselves who fascinated him so much as the image of them passed down by nineteenth-century artists."[87] Therefore, books in his personal library from this era such as the pictorial survey *Art of the Americas* (1948) may provide more clues as to his varied interests. The cross cultural comparisons of historic American art and folk art, Precolumbian, and native North American works may have intrigued Lichtenstein whose appreciation of the early cultures of Mesoamerica is evident in some of his sculptures of this period. Artifacts of the Northwest Coast, Southwest Pueblo and prehistoric Ohio Mound cultures are included, as well as a pictographic skin chart drawn by the Sioux Indians to record tribal history and important events.[88]

Art of the Americas also featured a carved Senecan tree-trunk mask with powerful abstracted forms that may have intrigued Lichtenstein. Nevertheless, his carved sculptures of this period, *Indian* (1952-1953, Cat. No. 11) and *Indian with Papoose* (1952-1953, cat. No.12) seem much more closely related to Picasso's sculptural innovations. Working with found objects, namely furniture parts, Lichtenstein has delicately carved Indian trademark images (feathered headdress, leggings, bow and arrow, child-carrying papoose) to create whimsical sculptures with a close resemblance to Picasso's elongated, schematic Boisgeloup sculptures of 1930-1931 (*Fig. 11*). Reminiscent of primitive sculptures, Picasso's crudely carved wooden sculptures had been featured in the magazine *Cahiers D'Art* in 1936.[89] One example (a bronze version) is reproduced in an exhibition catalogue owned by Lichtenstein, the Museum of Modern Art's *Sculpture of the Twentieth Century* (1952), to convey "the range of his surrealist experiments in sculpture."[90] Picasso's pioneering assemblages, such as his wood, multi-part *Mandolin* (1914), reproduced in the same book, likely served as the model for Lichtenstein's untitled construction (ca. 1955, Cat. No.13).[91] This untitled assemblage is evidently part of a series that Lichtenstein called his "splinters"

works. Roy and Marie Pearce have recalled that Lichtenstein referred to this type of work as part of his "splinters" series, "paintings [that] wouldn't be confined by frames, Roy's attempt at Abstract Expressionism."[92] Busche has referred to these constructions as "Lichtenstein's attempt to make it appear at least possible that they were objects created by Indians....aboriginal artifacts themselves" which are modernized and made of urban found objects, rather than the natural materials of Native Americans.[93] The untitled construction of ca. 1955 is very reminiscent of the mask or face of the katsina Crow Mother, who is the mother of all katsinas or spirit beings associated with the Pueblo cultures of the Southwest. Katsina masks, worn by costumed impersonators of these spiritual beings, are often made of painted canvas and objects like feathers, wood, and plant materials, in much in the same manner that Lichtenstein created this work.

In January 1953, Roy Lichtenstein's third one-man show in New York was predominantly comprised of paintings with American Indian themes. The sources for some of these works, particularly *Indians Pursued by American Dragoons (after Charles Wimar)* (1951, location unknown), were identified. The majority, however, were merely identified in terms of their subject, such as *Two Indians* (1952, most likely *Cat. No. 14*), later titled *Two Sioux*. The monumentality of these standing figures suggests the Indian portrait tradition of Catlin as exemplified in many plates of his *Letters and Notes on the Manners, Customs, and Condition of the North American Indians* (1841).[94] (See also *Cat. No. 39*) Another possible source would be the color plates reproducing a variety of Indian portraits (some full length) in Thomas L. McKenney's and James Hall's *The Indian Tribes of North America* (1836-1844 with subsequent reprints). In *Two Sioux*, Lichtenstein is again using the stereotypical imagery of the Plains tribes, with both figures wearing feathered headdresses. A shield appears in the hand of the left figure; the figure on the right wears a man's warshirt (with either painted lines or locks of hair) and a Navajo First Phase Chief's blanket. The Indians stand in front of a tipi, with stylized trees to the right.[95] This work was chosen by Roy Harvey Pearce for the cover of the 1988 reprint of his book *Savagism and Civilization: A Study of the Indian and the American Mind*.[96]

Lichtenstein's woodcut of 1952, *Two Sioux Indians* (*Cat. No. 15*) is derived from *Two Sioux*; the two figures and tipi beyond have been transformed through the imposition of Picassoesque stripes and typical decorative patterns associated with Navajo textiles that were traded

to Plains groups in the late 1800s. The figure to the left is wrapped in a Navajo trade blanket. The other figure wears fringed anklets (dance apparel), leggings, and a breech cloth with geometric beadwork or quillwork. These Plains Indians stand in front of a tipi, which is decorated with squiggles different from the typical geometrical pictographic images of war or hunting exploits sometimes painted on such structures (*Cat. No. 46*). Two other prints of the early 50s, *A Cherokee Brave* and *Two Indians (Two Indians with Bird)* (*Cat. Nos. 16, 17*) also demonstrate Lichtenstein's growing command of print-making and skillful assimilation of Indian design motifs.[97] They exhibit his use of feathers, geometric designs often found on Navajo textiles, and his use of the classic Northwest Coast eye shape. The use of hatched lines is also reminiscent of Southwestern Indian pottery—both the ancient Tularosa Black on White and the later fine line work that is associated with Acoma Pueblo. (See *Cat. No. 54*)

As the quintessential Plains Indians, the Sioux are also featured prominently in the paintings and works on paper of Alfred Jacob Miller (1810-1874) who in his travels West in 1837 observed their "classical form" and "statue-like, quiet dignity."[98] Miller's work may have also served as a model for Lichtenstein's depictions of Indian mothers and their children, one of which, *Navajo Mother and Child*, was in the Heller show.[99] The later *Untitled (Indian with Papoose)* (ca. 1956, *Cat. No. 18*) shows a mother holding a child tied into a carrying frame; ethnological details of feathers and a classic Northwest Coast eye shape are subsumed within the Synthetic Cubist geometry and ornamental patterning. The high-crowned cradleboard is typical for the Plateau area (See *Cat. No. 53*). Possible textile, bead, and/or porcupine quillwork is represented by the blanket that covers the child, wrapped securely on the cradleboard frame.

Also included in the Heller show of early 1953 was *Indian with Bird II* (1952, location unknown). The first version, *Indian with Bird I* (1952, *Cat. No. 19*), suggests Lichtenstein's fascination with Northwest design and imagery (*Cat. Nos. 35, 50, 53, 55*). It appears that a figure is wearing a large Bird Mask with feathers and displays the

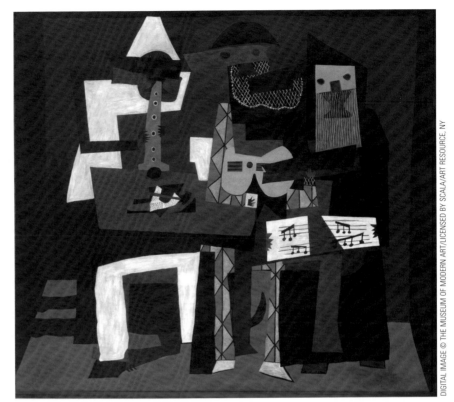

Fig. 12 Pablo Picasso
Three Musicians, 1921
Oil on canvas
79 x 87 3/4 in.
The Museum of Modern Art, NY
Mrs. Simon Guggenheim Fund (55.1949)
© 2005 Estate of Pablo Picasso/ Artists
Rights Society (ARS), New York

classic Northwest Coast eye design. Lichtenstein may have thought of the powerful examples of the Hamatsa Masks, or Cannibal society bird masks that he could have seen at the American Museum of Natural History. The geometric designs along the side of the mask may indicate the shredded cedar bark that is usually attached to these types of masks. The earth colors, combined with cool patches of blue and red reflect both the Northwest Coast and Lichtenstein's characteristic palette of this period. Another work on view was listed as *Algonquins Before Fort Mackinac* (ca. 1952, location unknown) which can be compared to the later watercolor, *Algonquins Before the Teepee* (ca. 1953, *Cat. No. 20*) in terms of a similar choice of subject. The reference to the Algonquins of the Northeast Woodlands may be intentionally broad. The figures are identified by such stereotypical shorthand signs as bows and arrows and feathered headdresses, which are not associated with that tribal group. The figure to the right wears what may be a hide or trade blanket; what appears to be a wigwam is in the background. Although it has not been possible to determine an exact source for this water-

color, it is possible that Lichtenstein excerpted images by Catlin and Miller of Plains Indian warriors and braves in front of tipis, as reproduced in various publications.[100] It is also possible that an illustrated volume of *The Song of Hiawatha* (1855) Henry Wadsworth Longfellow's epic poetic portrayal of the Indian as a noble savage, served as inspiration for Lichtenstein.[101]

Lichtenstein's second solo show at John Heller Gallery received generally positive reviews for his "boisterous canvases full of the American boy's fascination with our colorful origins," featuring "Indian life....with a curiously School-of-Paris look."[102] Lichtenstein "pretends at first to be interested in the illustrations of grammar-school history books, he pretends to be copying them but...the surprise is very funny, that what he is really thinking of is painting, and that he is an extremely sophisticated young man."[103] This comment was made by the painter-critic Fairfield Porter who also observed that Lichtenstein's adaptations of "naïve nineteenth century paintings" are rendered in a "style based on the flat Surrealist abstraction of Picasso, like the *Musicians* of the twenties."[104] (*Fig. 12*) By the time of Lichtenstein's next show in 1954, this "incongruity between style and subject" was articulated by the young critic and art historian Robert Rosenblum:

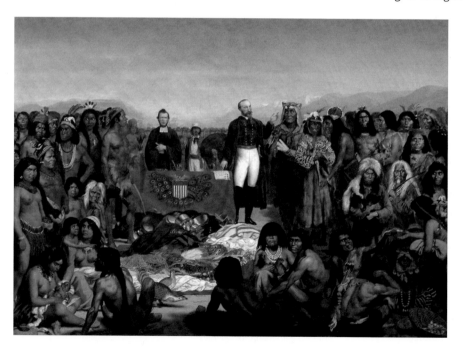

Fig.13 Charles Christian Nahl
South Idaho Treaty, 1866
Oil on canvas
27 x 36 1/2 in.
Gilcrease Museum, Tulsa, Oklahoma
0136.1481

Visually, they are skillful variations on a School of Paris theme, whereas their imagery is as remote from Braque and Picasso as are such typical titles of his as 'Weatherford Surrenders to Jackson' or 'Squaw with Infant.' Still, for all the irrelevance and at times even annoying quality of Lichtenstein's Americana in a l'art pour l'art context, the pictures are attractively composed of large flat color-planes into which the forms of his battle-scenes and Indian-lore are unobtrusively assimilated.[105]

Fairfield Porter also reviewed this show, perceptively observing that, in applying "a sophisticated manner to the corny," Lichtenstein was viewing his historical subjects as "an opportunity for making his own very different picture."[106] The artist was "innocent and sly," as he "transforms the meaning of things through his private and irreverent imagination."[107] Making fun of subjects that once had "a serious intention [now] lost to everyone, " Lichtenstein changes the faces of his sources into designs "devoid of ordinary psychology." [108]

Early in 1957, Lichtenstein had his final solo exhibition at the John Heller Gallery that was the last to feature what one critic referred to as "deliberate [Picassoesque] pastiches of obscure 19th-century American painters."[109] Holding "one's regard through the curious combination of authority and buoyancy," Lichtenstein's "paintings arrest the attention by their unconventionality."[110] Another critic found Lichtenstein "still engaged with his subject: a schoolroom, nineteenth-century view of the American Indian who was, after all, here first."[111] Three of the paintings shown "were done from big, official nineteenth-century canvases: *A Bad Treaty* had simple arrows between the parties to the treaty: the full regalia of an Indian, various deadly looking colonial officers."[112]

A Bad Treaty (ca. 1956, Cat. No. 21) is based on a recurring theme in Lichtenstein's work of this period and in American history painting from Benjamin West's *Penn's Treaty with the Indians* (1771-1772, Pennsylvania Academy of The Fine Arts) onwards: the signing of peace treaties with Indians, later broken by invading pioneers.[113] Lichtenstein based his work on Charles Christian Nahl's *South Idaho Treaty* (1866, *Fig. 13*) that documents a ceremonial

signing of the treaty between the United States and the Shoshone Indians, whereby they were offered $80,000 for Idaho land. The treaty was never ratified and Governor Lyon was charged with mishandling $50,000, as noted in a caption accompanying a reproduction of this painting in *Life* magazine in March 1954. Given that this painting was identified only as "A Bad Treaty" (and juxtaposed with "a good treaty" painting by Edward Hicks), the *Life* magazine reproduction likely served as Lichtenstein's source.[114] In keeping with the stereotypical simplification of the title, Lichtenstein greatly reduces the cast of many characters in Nahl's elaborate, romanticized painting to a central group of figures. To the left, a Shoshone Indian in headdress (on his back a quiver full of arrows) approaches a table covered with a cloth adorned with the official seal of the United States. Schematized almost beyond recognition, the seal is accompanied by multiple arrows that have been lain down (a symbol for peace?). Behind the table is a minister, Reverend Hamilton, one of the official representatives of the United States. To his right, stands, presumably Governor Caleb Lyon in a long coat, accompanied by what appears to be an officer with a scabbard and feather in his hat.

The atmosphere of tension in Nahl's original painting has been transformed in *A Bad Treaty* into a cryptic encounter of abbreviated figures rendered in a sketchy, loosely brushed manner. The wider range of colors, including sherbert orange and lemon yellow, suggests the impact of Matisse (whose retrospective of 1952 at the Museum of Modern Art was accompanied by a catalogue preserved by Lichtenstein).[115] Lichtenstein's freer brushwork is evident in other works of the later 50s such as *A Winnebago* (ca. 1956, *Cat. No. 22*), based on characteristic profile images of Sioux-related Indians (as can be found in the work of Miller and Catlin). It is tempting to interpret the feathered headdress, elaborate earrings, striped warrior face, and strong beak-like profile of this work as a kind of classic, stereotypical Plains Indian self-portrait, just as Lichtenstein had earlier depicted himself in the guise of a knight.[116] Lichtenstein may have been looking at Fraser's aforementioned buffalo/Indian head nickel for inspiration.

Lichtenstein's prints of this period such as *The Chief* (1956, *Cat. No. 23*) also reflect a new looseness, fluidity and breadth of space and scale that anticipates the Abstract Expressionist direction of his work in 1957. (Compare the full headdress of this work to the Plains Blackfeet example, *Cat. No. 45*). The painterly quality of Lichtenstein's work was commented upon in a review of his show of

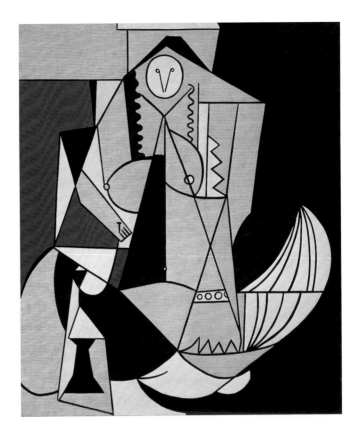

early 1957 that also proposed that "an undigested derivativeness of contemporary influence suggests this may turn out to be a transitional show."[117] Indeed the year

Fig. 14 Roy Lichtenstein
Femme d'Alger, 1963
Oil on canvas
80 x 68 in.
The Eli and Edythe L. Broad Collection,
Santa Monica, California

1957 proved to be a time of change for Lichtenstein who left Cleveland in the fall to take a position as assistant professor of art at the State University of New York at Oswego. Never having found fully satisfying employment in Cleveland, Lichtenstein was likely displeased as well with the general critical reception of his work there, which had generated controversy. In 1952, local critic Louise Bruner reviewed Lichtenstein's "fantasies of cowboys and Indians, or knights, castles and queens," on view in a one-man show at Art Colony Galleries.[118] Her comment on the collage drawing *Charging the Castle* (1950, Estate of Roy Lichtenstein) as "truly like the doodling of a five-year-old" received a significant number of positive and negative responses from local artists and readers, throwing Cleveland's "ordinarily sedate [and relatively conservative] art scene into the biggest donnybrook in years."[119] In addition to creating a humorous caricature of a cowboy shooting a pasted-up newspaper photo of Ms. Bruner, Lichtenstein provided a rare statement of intention that was published in the *Cleveland News*:

My purpose in painting is to create an integrated organization of visual elements.

In so doing, I deal with the relationship, size, shapes, brightness, and hue, these are the things which direct my decision within a painting...Subject matter, ideas, techniques, etc. bear no influence on any paintings I have done. If any of them appear in my paintings they have only been instruments of amusement, they do not direct one brushstroke I have ever made.[120]

Despite issuing this formalist statement that sounds like a manifesto for abstraction, Lichtenstein continued to paint and exhibit his Americana themes and Indian subjects with modest success. He received moderate praise for his "Injun feathers and dance rhythms."[121] Nevertheless, Lichtenstein in 1957 abandoned the Indian and American history themes that had preoccupied him for a considerable part of the decade. Although Lichtenstein had found his mode of working with pre-existing images of Americana, he had not yet found the way to work with his graphic sources' inherent qualities to forge an aesthetically viable congruity of high art style

and low art/high art subject that suited his considerable ambitions. That moment of concordance, nurtured by his years from 1960 to 1962 teaching at Rutgers University, would come with Lichtenstein's *Look Mickey!* (1961, National Gallery of Art) which the artist called his "first painting with no expressionism in it."[122] Yet in the mind of some critics such as Michael Kimmelman and even the artist himself, "it wasn't really a big leap" from his "themes of American folklore....to his paintings of the early sixties based on comic books and advertisements."[123] Lichtenstein himself observed in the early sixties, "I have always had this interest in a purely American mythological matter," referring to his works of the fifties as "mostly reinterpretations of those artists concerned with the opening of the West, such as Remington, with a subject matter of cowboys, Indians, treaty signings, a sort of Western official art in a style broadly influenced by modern European paintings."[124]

By the 1950s, as Busche has observed, Lichtenstein had already distinguished himself from most of the American art world by his consistent, "almost complete refusal to work from nature, his most far-reaching use of material already given artistic form....It was only after roughly 1960 that paraphrasing earlier works of art became more common."[125] Although his hero Picasso provided a venerated precedent in his parodies and transformations of the old masters, Lichtenstein was unusual in his reworking of reproduced artworks and magazine illustrations of questionable quality. Thus Lichtenstein had already established his unique persistence in reflecting upon the issue of art in reproduction as a ubiquitous fact of American life, ever since firms like Currier & Ives (1835-1907), the largest publisher of single-sheet prints, mass produced art for the homes of middle-class citizens, introducing millions to images of the mythic West.[126] The attendant confusions of truth and romantic reconstruction, of fact and clichéd ideal, and of real art and reproduction were issues already latent in Lichtenstein's early work that were clarified in his subsequent series of works.

Building upon the images from war and romance comics that established his reputation in the early sixties and "freed [him] from Cubism," Lichtenstein made a series of paintings, *Picasso Women* (1962-1964).[127] (*Fig.14*). His

Fig.15 Jay Van Everen
Amerindian Theme, ca. 1930
Oil and lacquer on masonite
46 1/4 x 45 3/4 in.
Montclair Art Museum, Museum Purchase, 1985.23

re-engagement with Picasso was both a way to get back in touch with the modernist art that first inspired him and to declare that his new style had considerably freed him from the burden of the master's influence.[128] With precise black outlines, Ben Day dots, and bold areas of primary colors, these works, referred to by Lichtenstein as "almost outright copies," reflect his fascination with "the simplicity of it all, the reductability of it all—black outlines and simple flat colors—like a comic strip, but still Picasso."[129] Rooted in popular conceptions of Picasso's work via reproduction—"not so much as they appear but as they may be understood—the idea of them....someone's funny idea of Cubism"—this series anticipated the kinds of "art about art" subjects that Lichtenstein would come to explore in the next decade.[130] This "kind of conception of the over-reproduced....repeated...by so many painters, that it finally lost its significance" was a guiding principle behind his emblematic series of paintings referring to popular modern artists and movements during the 1970s.[131]

The Amerind or American Indian Theme Series of 1979-1981

At the beginning of the decade following his ascendance as a pioneer of Pop art, Lichtenstein moved with his wife Dorothy to Southampton, Long Island. There in relative seclusion, he developed at least sixteen different series of "art about art" works which were examined by Jack Cowart in his groundbreaking traveling exhibition for The St. Louis Art Museum, *Roy Lichtenstein 1970-1980*, featuring the series *Trompe l'Oeil* (1973), *Cubism* (1973-1975), *Futurism* (1974-1976), *Purism* (1975-1976), *Surrealism* (1977-1979), *Amerind/Surreal Themes* (1979, 1981), and *Expressionism* (1979-1980). The largest series by Lichtenstein during the second half of the 70s was based on Surrealism, of which a group of American Indian-themed paintings, works on paper, and one sculpture form a kind of relatively unknown subsection. These fabricated works have been distinguished from their Cubist, Futurist, and Purist predecessors by their complexity of design and multiplicity of references.[132] Although the St. Louis exhibition received many reviews, there were no discussions of the few Amerind/Surreal works on view in which Lichtenstein updated his earlier interests in Western themes and American Indian culture, as perceived through the mass media intermediaries of reproduction, books, magazines, and popular culture.[133]

First coined in 1899 by Major John Wesley Powell, the unusual term "Amerind," which was attached to Lichtenstein's work of this period derives from "Amerindian,"

a combination of the words "American" and "Indian" that is more often used in discussions of tribal cultures in the Caribbean, Mexico, Central and South America.[134] Although not in common use in the United States, the term has precedents in the writings of Mary Austin who lamented the potential demise of Pueblo culture in her book *The Land of Journey's Ending* (1924):

> For this is what we have done with the heritage of our Ancients. We have laid them open to destruction at the hands of those elements in our own society who compensate their failure of spiritual power over our civilization, by imposing its drab insignia on the rich fabric of Amerindian culture....[135]

Around 1930, the artist and illustrator Jay Van Everen utilized this term in the title of one of his abstract Art Deco-stylized paintings inspired by Southwestern Native American art (Fig. 15).[136] In December 1943 the artist and primitive art collector Wolfgang Paalen published in Mexico a special double issue of the art journal *DYN* entitled the *Amerindian Number*. Containing articles, illustrations, and book reviews dealing with Northwest Coast art and a variety of other Native American subjects, *DYN* promoted the integration of "the enormous treasure of Amerindian forms into the consciousness of modern art."[137] The general use of "Amerindian" as a kind of umbrella term covering a variety of Native American cultures may well have appealed to Lichtenstein. His studio assistant at that time, Olivia Motch, has, however, cautioned reading too much into the use of the term "Amerind" which seems to have been primarily confined by Lichtenstein to the titles of three works from this series, *Amerind Figure*, *Amerind Landscape* and *Amerind Composition II* (Cat. Nos. 28, 33, 34).[138] It is possible that Lichtenstein's acquaintance with the artist, collector, and dealer Tony Berlant, from whom he purchased a Navajo blanket with a swastika motif (which for the Navajos was a sacred design referring to the four directions) was influential in this regard. While selling Southwest Indian objects during the late seventies, Berlant adopted the business name of Amerind Art, Inc.[139]

Using reproductions as what he called a "shorthand data transferral idea," Lichtenstein did not quote specific works of art in his "Amerind" series, but rather he excerpted and combined motifs as recontextualized in the many books in his library on American Indian design and Surrealism, mostly published in the 1970s—"a capacious, pre-existing fund of signs....in a continually unsettled state."[140] (Appendix I) The deliberately "pseudo-mechanical look" of Lichtenstein's work—"devoid of

HICKEY-ROBERTSON, HOUSTON

Fig. 16 Max Ernst
Capricorn, 1964
Bronze, cast IV/V
94 1/2 x 80 5/8x 51 1/4 in.
The Menil Collection, Houston X478
©Artists Rights Society (ARS), New York/ADAGP, Paris

emotional content"—was deemed relevant to "modern technology....[our] industrial-scientific age."[141] The artist's former painterly touch and palette of earth tones, enlivened by occasional Matissean colors had given way to his largely unvarying, unmodulated palette since the 60s of blue, red, yellow, and green, although with the sparing use of some subtler hues in the 70s.

By employing Surrealism as the "associative model" for his Amerindian works, Lichtenstein was provided with a liberating vehicle for combining allusive, fantastic images through poetic and irrational juxtapositions.[142] Bernice Rose, in her 1987 catalogue for Lichtenstein's retrospective of drawings, viewed "the Amerind series" as the "high kitsch" aspect of the Surrealist cycle, a "parody [of] 'primitivism' in both its psychological and anthropological senses."[143] Lawrence Alloway has similarly observed that the Amerind paintings, "as they echo his Modern paintings, have a kind of anachronistic ethnicity, just the kind of cultural play to stimulate

Lichtenstein's image-making facility."[144]

Lichtenstein affirmed this relationship to modernist primitivism in two interviews of the 1980s. In an interview of 1980, he recalled:

> *Max Ernst had some American Indian images. In the '50s I had done American Indian things that were very similar to these....[They] were cubist variations using Indian subject matter. In a sense, say that Picasso used African things, America made (use of) Indian things. However, I was still so heavily influenced by Picasso and expressionism that it was in spite of rather than because of the Indian subject matter.*[145]

In a rare extended interview in 1985 with Brenda Schmahmann, Lichtenstein observed in reference to his earlier American Indian-themed works, that he became interested in seeing "how some of the things I did in the 'fifties....would work in this new context (the Surrealist things are bigger compositions) and how I could use that sense of bigger composition to make these Indian designs."[146] It is likely that Lichtenstein's attention was directed to his earlier work by the contemporaneous research of Ernst Busche who was engaging the artist in an initially "not very welcome walk on memory lane" in preparation for his 1983 dissertation.[147]

Lichtenstein also mentioned the Surrealist Max Ernst's interest in American Indian art as another reason that led him to create the Amerind series: "somehow he made that connection [between American Indian art and Surrealism] and I see that you could make that connection."[148] Furthermore, Lichtenstein noted the analogous relationship between Cubism and "primitive" African art which had been used "so much"—evidently too much for Lichtenstein to work with it.[149]

The impact of Ernst's appreciation and collecting of American Indian art is suggested in a catalogue preserved in Lichtenstein's library, for Ernst's retrospective at the Guggenheim Museum in 1975. The artist is shown with one of the katsina dolls in his collection and the totemic aspect of his 1940s sculptures is discussed.[150] The curator of the Ernst show was Lichtenstein's close friend, Diane Waldman, who has acknowledged that she probably gave him a copy of the catalogue at the opening. Although Waldman and Lichtenstein did not discuss Ernst's interest in Native American art, she believes that "it's conceivable that there is some connection between Ernst's interest and Roy's return to the subject."[151] According to Waldman, Lichtenstein's Amerind series, which they did not discuss, was "part of his appetite for pre-conceived subject matter;" the artist "saw the beau-

ty of the motifs and what he could do with them" as he played with the "whole notion of translation" from one medium to another.[152] Lichtenstein's work was "always about formalism" and the publications in his library were "like style books for him."[153] Part of "the American conscience," the Amerind series did not provide a political or social statement, rather it belonged to the "level playing field" of art history from which the artist typically soon moved on to other subjects.[154] The art of the North American Indians, with their suggestions of biomorphic hybrids and metamorphosis, fascinated Ernst and the Surrealists from the very beginning of the movement. (*Fig. 16*) Hopi and Zuni Indian katsina dolls, as well as Eskimo and Northwest Coat masks and objects were included in the *Exposition Surréaliste d'Objets* in Paris in 1936, as noted in one of the surveys on Surrealism in Lichtenstein's library.[155]

For Lichtenstein, Ernst's involvement with American Indian art was one of "the clichés of surrealism" which interested him:

> I'm not interested in the Freudian dream phenomena or the psychological aspects as much as I am in the appearances of other art...the appearance devoid of its purpose.[156]

This concept of stereotypical representation is related to Lichtenstein's overall discussion of the Amerind series during his interview of 1985:

> They're just a mixture of every kind of Indian design from Northwest Indians to Plains Indians to Pueblo. They are no particular tribe of Indians. It's just everything that people vaguely associated with Indians.... Anything that I could think of that was "Indian" got into them.[157]

When later interviewed about his woodcut prints based on American Indian themes (1979-80), Lichtenstein observed that "they are definitely not an Indian's view of Indians."[158] Elaborating on his choice of theme, Lichtenstein stated:

> It's like seeing the Indian as if in the Museum of Natural History, not knowing which tribe he belonged to. All of the different tribes are mixed up to show the cliché idea of "Indian." There are Northwest Coast, Plains, and Hopi Indian characterizations.[159]

Lichtenstein also affirmed his interest in "the play of the Western or the European's view of the Indian against the Indian's view of himself."[160] This approach was observed by his studio assistant James de Pasquale who has commented that Lichtenstein was "making Cubist paintings with Indian ideas....turning them into

cartoons."[161] As Lichtenstein himself observed, "I've still got my early influence of cubist Picasso which I've been running away from all my life."[162] De Pasquale has also commented that "once in awhile there would be hints" in Lichtenstein's previous work of what was to come; for example, the final study for *Landscape with Figures* (1977, Shrensky Family Collection, Maryland) features a tipi in the center."[163]

Lichtenstein's return to American Indian subject matter in the late 70s coincided with the growth of Native American activism and an era of self-determination commonly known as the Red Power movement. Many articles in *The New York Times* publicized the activities of the American Indian Movement (AIM), whose leaders demanded radical changes in reservation policies and the honoring of treaty obligations. Among the most prominent leaders was Russell Means, an Oglala Sioux who led the revolutionary uprising at Wounded Knee on the Pine

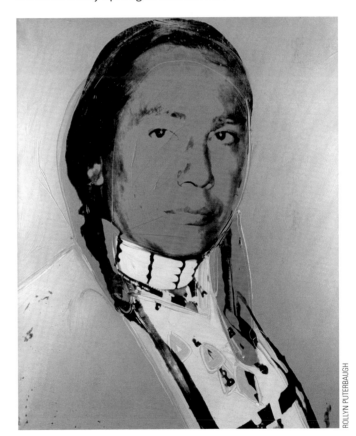

ROLLYN PUTERBAUGH

Fig. 17 Andy Warhol
Russell Means from the *American Indian Series*, 1976
Screenprint in colors and acrylic on canvas
84 x 70 in.
The Dayton Art Institute
Museum purchase with funds provided by the Kettering Fund, 1987.153
©1987 The Dayton Art Institute
© 2005 Andy Warhol Foundation for the Visual Arts/ARS, New York

LENORE SEROKA

Fig. 18 Roy Lichtenstein
*Razzmatazz,*1978
96 x 120 in.
Oil and Magna on canvas
Private Collection

the occasion of the American bicentennial. (*Fig.17*).
A good friend of the Lichtensteins and an avid collector
of American Indian art, Warhol painted portraits of
Dorothy and Roy in 1974 and 1976, respectively. Dorothy
Lichtenstein recalls that she and Roy possibly saw the
Means portraits at what may have been the first Paris
Art Fair in 1977.[164] Furthermore, one of the portraits was
reproduced on the inside cover of *Art in America* in March
1979, shortly before Lichtenstein likely began his
Amerindian series in April.[165]

Warhol's depiction of Means in traditional dress empha-
sizes the pride of the sitter who was chosen as emblem-
atic of the modern American Indian and can be viewed
as a poignant social commentary at a time when "Indian
groups and individuals...[were] searching for identity
through redefinition of cultural values."[166] Warhol also

Ridge Reservation in South
Dakota during the spring
of 1973. His portrait was
painted by Andy Warhol in
a series of 1976 called *The
American Indian,* created on

portrayed two other well-known Native Americans, the
artists Fritz Scholder (1979-1980) and R.C. Gorman
(1981).[167] Although Warhol's portrait approach differed
from Lichtenstein's Amerind subjects, perhaps these
works at least reinforced the resurgence of interest in
American Indian themes at this time.[168] This interest may
have also been stimulated by Lichtenstein's proximity to
the Shinnecock Indian reservation where he and Dorothy
attended some pow wow ceremonies, although these
experiences have been said to have had no impact on his
particular choices of American Indian imagery.[169]

In addition to his contact with Tony Berlant, Lichten-
stein's friendship with the curator, dealer, and collector
Jonathan Holstein was particularly significant. Recalling
the 1970s as an era when "an intense re-evaluation of
primitive art in relation to high art was very much hap-
pening," Holstein exposed Lichtenstein to his own collec-
tion of Native American art.[170] He also accompanied
Lichtenstein to the Heye Foundation/Museum of the
American Indian and to the American Museum of Natural
History where Holstein worked on the reinstallation of
the halls of ancient Mexican and pre-Columbian art.

Lichtenstein preserved an inscribed copy of Holstein's *Abstract Design in American Quilts* (1971), the catalogue for an exhibition at the Whitney Museum of American Art, and may well have seen *Five Hundred Years of Native American Art* there in 1972.[171] Holstein has recently observed that Lichtenstein's "involvement with Native American material was a natural outgrowth of his interest in all design and art traditions."[172] Recalling that Lichtenstein knew the American Museum of Natural History "and its Northwest Coast collection well," Holstein noted that they "also discussed Native American art at various times."[173] Although Holstein does not claim that the Native American objects seen by Lichtenstein in his apartment are "what interested him in the subject," they were "occasionally a stimulus for conversation among us about Indian art."[174] He has concluded that "Roy's great sense and exploration of cultural icons no doubt drew him to Native American art in the first place, and he used the images he chose skillfully, transmogrifying them with his usual visual acuity and sense of irony."[175]

In the late 70s, Native American art and culture were highly visible, thanks to a variety of exhibitions and publications, a number of which were collected by Lichtenstein and likely served as his source material (Appendix I). He distinguished the Amerindian series from previous works in the Surrealist series as tending "to be very geometric."[176] Looking "through a lot of books," Lichtenstein expanded upon the repertoire of American Indian symbols, especially "from pottery or weaving," and "invent[ed] out of that...try[ing] to get what's typical of it and what looks Indian about it."[177] Lichtenstein also observed that he "made figures out of things (the braid, the eye, the eyebrow becomes a figure) that generally they wouldn't have done."[178] Thus *Head with Braids* (1979, Cat. 24) incorporates an invented, clichéd motif—"you associate braids...with Indians."[179] The blonde color of the braids is based on similarly colored locks of hair that function as female symbols in Lichtenstein's earlier Surrealist works.[180] The geometric triangular design suggests stylized feather motifs; the hand is rendered as a stylized bear paw shape. The depiction of the head as a *trompe l'oeil* heavily grained plank of wood recalls both Lichtenstein's earlier Surrealist works such as *The Conversation* (1977, Private Collection) or *Razzmatazz* (*Fig. 18*) and their likely source—René Magritte, whose relevant works, such as *The Conqueror* (1925), was reproduced in several of the Surrealist books owned by Lichtenstein.[181] Furthermore, the wooden plank is a typical kind of self-quotation that refers back to Lichtenstein's *Trompe L'Oeil* stretcher bar/picture back series of 1973, inspired by the American 19th-century painters John Frederick Peto and John Haberle.[182]

Face and Feather (1979, Cat. No. 25) combines the iconic North American Indian image of a feather with an eye with South American Indian symbols from ancient Paracas textiles and ceramics found in Peru. The geometric mouth shape is a close copy of the mouth design found on the mythological animal featured on the prehistoric pottery from Tiahuanaco (a major site in Peru) that Lichtenstein had likely marked with a slip of paper in his book, *Ancient Art of the Andes*[183] (Cat. No. 36). In *Composition with Two Figures* (1979, Cat. No. 26) Lichtenstein referred to "the sexist or clichéd way of thinking of male and female," presenting the man "looking like a [*trompe l'oeil*] board" and the woman as "looking flowery."[184] Identified as an Indian brave by his headdress of feathers, the angular woodgrained male interacts with the curvaceous female whose eye design is based upon a detail of a shirt from Tiahuanaco, reproduced in Le Roy H. Appleton's *American Indian Design & Decoration* in Lichtenstein's library.[185] This stylized female figure is an adaptation of the curvilinear "Rain bird" motif from a ceramic pot reproduced in H.P. Mera's *Pueblo Designs: 176 Illustrations of the "Rain Bird."*[186] (Cat. No.38). It is likely coincidental, but nonetheless noteworthy that Lichtenstein used the same colors that are associated with the sacred directions in Puebloan thought.[187]

The hatched, potsherd-like, jigsaw pieces in *Composition with Two Figures* are reminiscent of the line designs found on both prehistoric and modern American Indian pottery from Acoma and Zuni Pueblos in New Mexico, as reproduced in various sources. (*Cats. No. 47, 48, 54*) Lichtenstein has referred not only to the subjects of these reproductions but also their inherent qualities as he enlarged and reordered their images, accentuating their bold, graphic style and systematic cross hatching and stripes—both of which were already trademark aspects of his work, referring to commercial art techniques and imagery. Thus, as Schmahmann has observed, Lichtenstein evokes associations between "primitive" art (the Pueblo source), "high" art (his own work), and "low art (commercial art)."[188]

Lichtenstein's tendency to work with the visual language of reproductions is evident in a sketchbook of 1979 that is full of American Indian motifs drawn in pencil. (*Cat. No. 27*). For example, he has carefully copied, with slight variations, designs commonly found on Southeastern gorgets, carved shell accessories usually worn around the neck of a high ranking individual or spiritual leader, with incised geometric designs of supernatural beings, reproduced in Maria Naylor's *Authentic Indian Designs*, another Dover classic.[189] This sketchbook page also shows one

Southwestern geometric pottery design, a stylized bird/cloud design. Lichtenstein's playful figurative approach to his American Indian sources is extended in the bronze sculpture *Amerind Figure* (1981, *Cat. No. 28*). It is part of a series of planar heads of the 1980s which "range freely through stylistic quotations of German Expressionism to Pop Surrealism, incorporating American Indian and curvilinear motifs, to evocations of Brancusi and Archaic Greek pottery painting."[190] The zig zag linear figure is identified as Indian by means of a prominent eye derived from Northwest Coast imagery. A curvilinear mark above the eye doubles as a feather and an eyebrow, as observed by Lichtenstein in relation to his prints: "[It's] like a Northwest Coast totem pole eye, except it has...an eyebrow. Mine is definitely a cartoon eyebrow."[191] The prominence of eye forms in both this sculpture and the two dimensional works can also be seen as a reference to Surrealism.[192]

In works such as *Indian Composition* (1979, *Cat. No. 29*) and the woodcut *American Indian Theme II* (*Cat. No. 30*), figurative references are assimilated into a Cubist-Surrealist patchwork of abstracted, iconic images such as bear claws. *American Indian Theme II* is part of the *American Indian Theme* series begun at Tyler Graphics in the spring of 1979 and completed in 1980. Furthermore, Lichtenstein produced six intaglio prints with American Indian subjects during this same period, also closely related to his contemporaneous paintings.[193] Ken Tyler has recalled that he brought Lichtenstein's earlier woodcut *A Cherokee Brave* (*Cat. No. 16*) to the studio around 1980 "to show everyone and it was talked about while we were working on the prints."[194] Returning to the subjects and media of his earlier series of the 1950s, Lichtenstein also established the foundation for his next series of works inspired by German Expressionist woodcuts and paintings.[195]

In *Indian Composition*, a possible encounter of male figures (left) and female figures (right) is subsumed within the cacophony of images derived from Southwestern pottery designs and Peruvian art. The same eye and mouth motif from Paracas textiles and ceramics in Peru are used in the figures, along with Southwestern pottery hatched lines, zig zags (often a symbol for lightning), crosses symbolizing the four directions, and bear paw designs. *American Indian Theme II* again employs the hatched motifs often found on Puebloan ceramics. A central figure, similar to the bird/cloud designs often found on the interior of Puebloan bowls, has a face reminiscent of some katsina figures. This figure seems to float against a prickly cactus type design. The figure is juxtaposed with a grouping of bear claw prints, a con-

ventionalized sky and cloud formation, as well as a canoe. Lichtenstein later referred to this "representation of a canoe, but it's more a European's view of a canoe"—part of his repertoire of invented shapes that evoke American Indian culture.[196] This stereotypical canoe image is also featured in *Little Landscape* (1979, *Cat. No. 31*), along with stylized mountains, a thunderbird motif, and sacred four direction crosses as stars in the night sky. A saguaro cactus is also evident, a typical plant for the Sonoran Desert; bird tracks, a common motif on some pre-contact Southwestern pottery, are also apparently leading away from the cactus.[197] Stereotypical geometric designs often found on basketry and textiles from the American Southwest, incorporated into a tipi design and border, complete this work.

Mythological Meeting (1979, *Cat. No. 32*) is very similar to images of fish from the coast and mountains of Peru, often found on textiles from this region.[198] This image is also similar to lightning designs used by various tribal groups. The composition also suggests the appearance of stylized mountain ranges (divided into black and blue areas) with the two mythological beings of lightning and thunder in the sky who maintain a cosmic balance between heaven and earth through their struggle. The hatched pottery lines, a distinctive Lichtensteinian motif, are in the background with a curvilinear band of white near the top, likely a cloud formation.

In the monumental tapestry *Amerind Landscape* (1979, *Cat. No. 33*), Lichtenstein combines clichéd notions of male and female types with references to Peruvian textiles, southwestern black-on-white pottery designs, a stereotypical Plains tipi with open flaps and a bear paw nearby, and stylized pottery bird images. The female with her Surrealist hank of blond hair is defined by a curvilinear "rain bird" motif from which feathers protrude.[199] Her eye and the possible beak-like shape (formed by the top of the curve and center section of hair) is reminiscent of Northwest Coast totemic art. *Amerind Composition II* (1979, *Cat. No. 34*) is also based on the "rain bird" motif, with stylized wings incorporating rain clouds defined characteristically by hatchmarks suggestive of Southwest Pueblo ceramics. A pair of yellow, red, black, and white geometric forms to the right evoke dance wands utilized for rites to bring rain. The notion, however, of these elements forming a kind of visual prayer for rain was foreign to Lichtenstein who was, in his words, "trying in a sense to erase the meaning of the originals."[200]

The first to identify Lichtenstein's use of the "rain bird motif," Brenda Schmahmann has related his choice of bird imagery to Max Ernst's Loplop figures, an alter ego

and personal totem that first appeared in his work of the late 1920s. Schmahmann also cites Ernst as a source for Lichtenstein's non-hierarchical approach to imagery "in favour of a process of formal and iconographic co-option....the product of collectively defined sign systems."[201] She sees this process as parallel to that of the "Pueblo potter [who] does not endeavor to achieve individual expression, but rather creates images which conform to collective needs."[202]

Schmahmann has observed that Lichtenstein juxtaposed male "Cubist" and female "Surrealist" figures to question the clichéd opposition of distinct romantic/intuitive and classical/rational approaches to artmaking.[203] Taking this observation further, it is possible to assert that Lichtenstein's appropriations of geometric and curvilinear/organic forms in American Indian art afforded him the opportunity to refer to the publicly defined conceptions of opposition associated with these movements and to achieve his uppermost goal of a complex pictorial unity. By using precoded images to create new associations, Lichtenstein seems to have suggested that contemporary "visual content or iconography is created through the adaptation and relocation of [collective] signs existent within society, rather than through the creation of original forms....that are authentic manifestations of his personal feelings."[204]

Several of Lichtenstein's Amerindian paintings were exhibited in the spring of 1979 at Leo Castelli Gallery, as well as in one-man shows in 1980 at the University of Wisconsin, Eau Claire, and the Portland Center for the Visual Arts.[205] His *Study for Two Figures, Indian* (1979) was featured in *Symbols and Scenes: Art by and About American Indians*, a permanent collection-based show at the Corcoran Gallery of Art in 1980.[206]

The Amerind series received surprisingly little critical attention; if mentioned at all they were commonly seen as just one of many versions of Lichtenstein's prolific interpretations "from a decade of table-hopping through art history:"[207]

> These new paintings continue the artist's investigation of the codes which inform our understanding of visual information....And since his technique is by now so well known, it has become virtually transparent, allowing him to display structural and thematic similarities across the whole range of visual culture. Thus he can join elements like the Late Synthetic Cubism of Picasso, the biomorphic forms of Surrealism, the figure style of Leger, Minoan portraits busts, primitive pattern-making [e.g. from American Indian sources] and even little snippets from his own past, and so indicate

> certain formal relationships...plac[ing] his ironic scrutiny of American life within a larger context.[208]

> In his recent work, Mr. Lichtenstein has returned to what might be considered a more typical approach, creating elaborately detailed canvases using Native American designs as a point of departure. He has always been an artistic cannibal, making paintings and sculptures about other painters' paintings, and painted images about printed images, decorative devices—whatever captures his fertile imagination.[209]

> The current show [at the Whitney Museum] delves heavily into Lichtensteinian versions of surrealism, German Expressionism, purism, cubism, futurism, American Indian painting...[210]

> Lichtenstein is most interested in grabbing onto the cliché 'look' of surrealism in his works, not the surrealist philosophy....the 1979-80 works in the show are bizarre. On the identification level, you could say he is dealing with American Indian motifs: teepees, arrows, feathers, thunderbirds, fringes, and various geometric designs. But these things are all scrambled together, or-more to the point-almost woven together. It's almost as if Lichtenstein were making surrealist works with Indian symbols. Maybe he is.[211]

> Lichtenstein presents recent art history as a ready-made....Not since Duchamp...has an artist treated the subject of art with such sweeping irreverence.[212]

Conclusion

In 1982, a retrospective at the Parrish Art Museum afforded Lichtenstein the first opportunity to look at his pre-Pop work within the context of his later achievements. Lichtenstein's paintings of the 1950s were seen as precursors of his fascination with "the stereotypic image" and "a pull back and forth between the [modernist] idiom and the subject matter that is to this day the motor force in [his] work."[213] The American Indian subject was noted as "a theme he picked up again in the late 1970's;"[214] a couple of early and late works were contrasted to one another:

> A painting like "Amerind Composition II" of 1979 gives, for instance, a heraldic or blazonlike air to American Indian subject matter that was treated more picturesquely in the two paintings of the '50s called "Squaw with Papoose."[215]

This juxtaposition of early and recent works was, for the most part, not provided in the large survey of his work at the Guggenheim Museum in 1993. Lichtenstein was, however, credited by one reviewer with "appropri-

ating years before that word acquired a halo" when he "painted Picassoid versions of discredited 19th-century American history paintings"in the 1950s.[216] A full-scale retrospective of Lichtenstein's prints at the National Gallery of Art in 1994 drew somewhat more attention to the artist's early "little-known...endearing, slightly cari-caturish images of...headdress-wearing American Indi-ans....[which] demonstrate an innate attraction to manipulating both popular imagery and popular cliché..."[217] When asked to comment upon the relation-ship between his works of the 1950s and the later Amerindian series, Lichtenstein himself observed:

> Well the 'fifties things were influenced by Picasso, Braque or Klee or somebody. The paint texture, modu-lation and color was subtler, and I really thought I was painting then. These are without texture and they have a mechanical look as if they're mechanically done. [There] is not much other difference though. The sense that you could make figures out of say an Indi-an blanket design was the same notion then....[I]t was surreal even then—I didn't realize it was—but it could have been from Picasso's Surrealism... This [points to Face and Feather (1979, Cat. No. 25)] I turned into my own while that [points to Indian (1951)] is still highly influenced.[218]

Although stylistically divergent, the early and later mature works share the artist's interest in a "highly charged subject matter carried out in standard, obvious, and removed techniques."[219] Lichtenstein's detached han-dling of iconography symbolized the industrial "world

we live in rather than the more romantic [world of] Picasso."[220] Referring to other art with a sly humor and sense of irony, Lichtenstein paraphrased and altered both discredited and revered images "to erase the mean-ing of the originals" and create a new formal unity.[221] This resulted in Lichtenstein's unique marriage of repre-sentation and abstraction, high art and popular culture. Referencing how our perceptions are shaped by com-mercial printing techniques and mass media, Lichten-stein developed a cool, intellectual, impersonal style that was nevertheless instantly recognizable as his own. Lichtenstein's sustained dialogue and ongoing encoun-ters with American Indian art and culture was a relative-ly unknown yet vital component of his desire to "make...work that would stand on its own made out of the clichés of thinking about" this kind of imagery, as usually seen secondhand in reproductions.[222] Not engaged in social commentary, Lichtenstein was aware that his works "definitely [did] not [present] an Indian's view of Indians."[223] Fascinated with "the cliché of the Indian.....what looks Indian about it," Lichtenstein freely combined motifs from various North and South American Indian cultures with invented, iconic signs and symbols, playing "the Caucasian or the European's view of the Indian against the Indian's view of him-self."[224] Ranging from the noble savage myths of west-ward expansion to contemporary stereotypes, Lichtenstein's series of the 1950s and 1979-1981 epito-mize his lifelong engagement with what he called "a purely American mythological [subject] matter."[225]

Footnotes

1 Dorothy Seiberling, "Is He the Worst Artist in the U.S.?," *Life* 56 (January 31, 1964): 83.

2 David Shapiro, "High Unity: An Interview with Roy Lichtenstein," 1970s, unpublished manuscript, pp. 6,8, courtesy of the Roy Lichtenstein Foundation, hereafter cited as RLF.

3 Kay Larson, "Art," *New York* (September 21, 1981): 34-35.

4 John Coplans, "An Interview with Roy Lichtenstein," *Artforum* 2 (October 1963): 31.

5 Ernst Busche, *Roy Lichtenstein: Das Fruhwerk, 1942-1960* (Berlin: Gebr. Mann Verlag, 1988): 3 (Foreword and Acknowledgements). All page references are to the English translation by Russell Stockman, courtesy of RLF. See also Deborah Solomon, "The Art Behind The Dots," *The New York Times Magazine*, March 8, 1987, p. 112 for the artist's reticence about his past.

6 Brenda Lynn Schmahmann, *Roy Lichtenstein's Critique of Modernist Theories: The Post-1960s Works* (Master of Arts dissertation, University of the Witwatersrand, Johannesburg, 1987): 169, RLF.

7 David Shapiro, op cit, p. 7.

8 See Aldona Jonaitis, *From the land of the totem poles: The Northwest Coast Indian Art Collection at the American Museum of Natural History* (Seattle: University of Washington Press, 1988): 236-242, passim (view of the North Pacific Hall, 1943 on p. 236).

9 Richard Brown Baker, Interview with Roy Lichtenstein, November 20, 1963, p. 46, Archives of American Art, RLF transcript. See also Ernst Busche, 1988, op cit, pp. 5-6 (I. Biographical Notes), 111 (Chapter IV, 2. *The American West*).

10 Amei Wallach, "Lichtenstein and life after pop," *Newsday*, September 20, 1981, Part II, p. 20. See also Michael Juul Holm ed. et al, *Roy Lichtenstein All About Art* (Louisiana Museum of Modern Art, Denmark, 2003): 134.

11 Quoted in Calvin Tomkins, *Mural with Blue Brushstroke* (New York: Harry N. Abrams Publishers, Inc., 1987): 14. For Lichtenstein's comments on Marsh and his decision to go to Ohio State, see Richard Brown Baker, op cit, pp. 36, 44, 76, 78-80. See p. 79 on Lichtenstein's having received Craven's book and its "berating comments" on Picasso. On Marsh and his break with European modernism as "the New Deal in American art," see Thomas Craven, *Modern Art* (New York: Simon and Shuster, 1934): 331. Lichtenstein's student card indicating his studies with Marsh from July 1 to August 9, 1940 is on deposit at the Art Students League, copy courtesy of Pamela Koob, curator, who in a letter of November 19, 2004 confirmed the realist orientation of the instructors at the League.

12 G.R. Swenson, "What is Pop Art?," *Art News* 62 (November 1963): 62. Ernst Busche, op cit, Chapter II, pp. 4-27.

13 Hoyt Sherman, *Cézanne and Visual Form* (Columbus: The Institute for Research in Vision, Ohio State University, 1952): 10. For more on Sherman, especially his influential Visual Demonstration Center, see Bonnie Clearwater, *Roy Lichtenstein: Inside/Outside* (North Miami: Museum of Contemporary Art: 2001): 10-53 and Russell Ferguson ed., *Hand-Painted Pop American Art in Transition 1955-1962* (Los Angeles: The Museum of Contemporary Art, 1992): 103-105. On Sherman's heightening of Lichtenstein's awareness of how different reproductions could be from the originals, see Ernst Busche, op cit, Chapter IV, (2, *The American West*), p. 111.

14 Elizabeth Gardner, *Art through the Ages An Introduction to its History and Significance* (New York: Harcourt, Brace, and Company, 1936): 534-563 (American Indian art), 724. RLF. The Picasso works that are cut out are Fig. 866 *La Table* (1920, Smith College Museum of Art) and Fig. 867 *Abstract* (1930, listed as Valentine Dudensing Gallery, New York). For confirmation of his Columbus address, see Clare Bell, "Chronology," RLF website, section for 1942, p. 5.

15 *Roy Fox Lichtenstein, Paintings, Drawings, and Pastels*, M.F.A. thesis, 1949, pp. 1-4,6-7, copy courtesy of Pat McCormick, Archives, The Butler Institute of American Art.

16 Ernst Busche, op cit, III. *Earliest Works*, p. 34. See also pp. 52, 55-56.

17 Quoted in Mary Lee Cortlett and Ruth Fine, *The Prints of Roy Lichtenstein A Catalogue Raisonné 1948-1997* (New York: Hudson Hills Press in association with the National Gallery of Art, 2002): 16.

18 Avis Berman, Interview with Roy Harvey Pearce, August 21, 2001, p. 29-30, RLF and Gail Stavitsky, Interview with Roy Harvey Pearce, July 2004, p. 1. For Busche's discussion of Lichtenstein in relation to Abstract Expressionism and myth, see Chapter III, pp. 43-49.

19 Berman interview, op cit, p. 30.

20 Ibid, p. 39.

21 Lawrence Alloway, "Roy Lichtenstein's Period Style," *Arts Magazine* 42 (September-October 1967): 24-29.

22 Roy H. Pearce, *The Savages of America: A Study of the Indian and the Idea of Civilization* (Baltimore: The John Hopkins Press, 1953): 109. See also Henry Nash Smith, *Virgin Land. The American West as Symbol and Myth* (New York: Vintage Books, 1950): 204-7, passim.

23 Quoted in ibid, p. 112.

24 See Bernard De Voto, *Across the Wide Missouri* (Boston: Houghton Mifflin Co., 1947): 392; Oliver La Farge, "George Catlin: Wild West witness," *Art News* 52 (October 1953): 30-32, 66 and citations in *Art Index*, (New York: The H.W. Wilson Company, 1951): 1947-1950, p. 269; 1953-1955, p. 186.

25 Alfred H. Barr Jr., "Preface," *Romantic Painting in America* (New York: The Museum of Modern Art, 1943): 5.

26 Quoted in William Cronon, "Telling Tales on Canvas: Landscapes of Frontier Change," *Discovered Lands Invented Pasts Transforming Visions of the American West* (New Haven and London: Yale University Press, 1992): p. 50.

27 Bernard De Voto, op cit, p. 392.

28 Nancy K. Anderson, "Curious Art Historical Data: Art History and Western American Art," *Discovered Lands...*, op cit, pp. 1-36.

29 Richard Aquila ed., *Wanted Dead or Alive: The American West in Popular Culture* (Urbana: University of Illinois Press, 1996): 8, 254.

30 Nancy K. Anderson, op cit, pp. 29-31.

31 Unpublished interview, January 26, 1990, p. 2, RLF.

32 Edward Bruce and Forbes Watson, *Art in Federal Buildings*, Vol. 1 Mural Designs, 1934-1936 (Washington D.C.: Art in Federal Buildings, Inc., 1936), n.p., passim, see designs by Fiske Boyd, Orville Carroll, Thomas Donnelly, Joseph Fleck, Karl R. Free, Lowell Houser, Stephen Mopope, and others.

33 Henry Adams, *Thomas Hart Benton: An American Original* (New York: Knopf, 1988): 324, see also pp. 128ff, 186 (Indian Arts), 201, 206, 253, 264. For the frequent reproduction of these images, see *Art Index*, 1929-37.

34 Richard Brown Baker, op cit, p. 75. See also Diane Waldman, *Roy Lichtenstein* (New York: Harry N. Abrams, Inc., 1971): 25: "There was a lot of regional painting (Grant Wood, not Remington) still lingering in the 1940's in the mid-West but we were never very interested in it."

35 Elizabeth Gardner, op cit, p. 689.

36 David Shapiro, op cit, p. 4.

37 Gail Stavitsky, telephone interviews with Joe O'Sickey, July 21, 2004 and March 29, 2005.

38 Gail Stavitsky, telephone interview with Sidney Chafetz, October 15, 2004. See also Sidney Chafetz, "Four Early Lichtenstein Prints," *The Artist's Proof X* (1970): 48-51.

39 Stavitsky interview, op cit, p. 3.

40 Helen A. Harrison, " A Look at Roy Lichtenstein's Rarely Seen Art," *The New York Times*, August 8, 1982, L.I. section, p. 1.

41 Calvin Tomkins, "The Prince of Pop," *Vogue* (September 1993): 521.

42 Ibid.

43 Ibid.

44 Diane Waldman, op cit, p. 25.

45 Quoted in Helen A. Harrison, *Larry Rivers* (New York: Harper & Row Publishers, 1984): 35.

46 See Ernst Busche, op cit, pp. 3-6 (IV. *Americana 1. Early American History and Battle Scenes*), 100, IV. (2. *The American West*) and Diane Waldman, *Roy Lichtenstein* (New York: Solomon R. Guggenheim Museum, 1993): 6.

47 Sidra Stich, *Made in U.S.A. An Americanization in Modern Art The '50s and '60s* (Berkeley: University of California Press,1987): 17. On Lichtenstein's eventual friendship with Rivers, see Deborah Solomon, "The Art Behind the Dots," *The New York Times Magazine*, March 8, 1987, p. 46, River's comment-"Roy got the hand out of art and put the brain in."

48 Ernst Busche, op cit, Ch. IV, part 1, p. 2.

49 Diane Waldman, 1971, op cit, p. 25.

50 Hoyt Sherman, untitled essay, *Recent Paintings: Roy F. Lichtenstein*, John Heller Gallery, New York, December 31-January 12, 1952, n.p.

51 Carlyle Burrows, "Two Artists," *New York Herald Tribune*, Sunday January 6, 1952, Sec. 4, p. 6.

52 J.F., "Roy Lichtenstein," *Art Digest* 26 (January 1, 1952): 20.

53 Ibid. See also reviews by Fairfield Porter in *Art News* 50 (January 1952): 67 and in *The New York Times*, January 6, 1952, p. X9.

54 Elizabeth Gardner, op cit, p. 676.

55 "The American Revolution," *Life*, 29 (July 3, 1950): 50.

56 Kathleen H. Pritchard, "John Vanderlyn and the Massacre of Jane McCrea," *Art Quarterly* XII (Autumn 1949): 365. For the use of the title *The Death of Miss McCrea* in relation to American engravings after Robert Smirke's version of this subject, see p. 365. For the Currier print and Robert Smirke's popular variation on this subject, see Samuel Y. Edgerton, Jr., "The Murder of Jane McCrea: The Tragedy of an American Tableau Histoire," *Art Bulletin* XLVII (December 1965): 483, 486-488 (p. 482 illustration of *Death of Jane M'Crea, from Lossings's Our Country*, 1888.)

57 Michael Cronon, 1992, op cit, p. 51 and Samuel Y. Edgerton, op cit, p. 486. See also Ernst Busche, op cit, Chapter IV, p. 32.

58 Ernst Busche, op cit, p. 83 (IV, part 2 *The American West*).

59 Ibid, p. 95-"Lichtenstein could well have been drawn to a picture like Bierstadt's *The Last of the Buffalo* after studying Picasso's pictures of bullfights."

60 Peter Hassrick, *The Way West Art of Frontier America* (New York: Harry N. Abrams, Inc., 1977): 126.

61 Ibid.

62 See Rena Coen, "The Last of the Buffalo," *American Art Journal* 5 (November 1973): 83-94. Lichtenstein could have seen Bierstadt's painting reproduced in Virgil Barker, *American Painting* (New York: The MacMillan Company, 1951): 589.

63 Carlyle Burrows, 1952, op cit.

64 Bernard DeVoto, 1947, op cit., pl. xxxix, p. 403.

65 Ibid, pp. 135, 138.

66 See Ernst Busche, op cit, pp. 37-39 (Ch. IV, part 2) for a discussion of this work. For a possible source image, see Harold McCracken, *Portrait of the Old West* (New York: McGraw Hill Company, Inc., 1952): 75,81.

67 Ibid, p. 33.

68 See Martin H. Bush, *James Earle Fraser: American Sculptor* (New York: Kennedy Galleries, Inc.), June 2-July 3, 1969, pp. 5-7,14-17,59-63 and Judith A. Barter, *Window on the West/Chicago and the Art of the New Frontier 1890-1940* (The Art Institute of Chicago, 2003): 14,15,151.

69 According to the RLF, there are two charcoal drawings that are studies (#4299, 1587) and two other works on paper-Cat. No. 9 and another variant in the collection of the Cleveland Museum of Art.

70 Richard Brown Baker, op cit, p. 74 and Alfred H. Barr, Jr., *Picasso: Forty Years of His Art* (New York: The Museum of Modern Art): 60-64, also 169 (*Minotaurmachy*), pp. 174-181 (*Guernica* and studies).

71 Ernst Busche, op cit, p. 92 (Ch. IV, part 2). Klee's *Picture Album* (1937) was reproduced in Alfred H. Barr, Jr. et al, *Paul Klee* (New York: The Museum of Modern Art, 1945): 57.

72 Quoted in Barbaralee Diamondstein, "'He gave us what Einstein gave to science,'" *Artnews* 73 (April 1974): 45-46. For Klee's influence see John Gruen, "Roy Lichtenstein: From outrageous parody to iconographic elegance," *Art News* 75 (March 1976): 40: "I did paintings of cowboys and Indians. They looked like official American paintings, but also looked Cubist, on their way toward becoming expressionist. Actually, they were influenced by just about everybody from Picasso to Klee."

73 Alfred H. Barr, Jr., *Picasso*, op cit, pp. 48-49.

74 Jean Cassou, *Picasso* (Paris: Collection Des Maîtres, 1949), n.p.

75 Alfred H. Barr, Jr., *Picasso*, op cit, p. 175. For other early Picasso books in Lichtenstein's library, see Jaime Sabartes, *Paintings and Drawings of Picasso* (Paris: Braun & Cie, 1946) and Christian Zervos, *Dessins de Picasso 1892-1948* (Paris: Editions "Cahiers D'Art," 1949).

76 See Ernst Busche, op cit, Ch. IV, part 1, pp. 13-14, 18, 20 for Lichtenstein's frequent use of the *Album of American History* and its offset, formulaic printed images.

77 *Album of American History*, Volume II 1783-1853 (New York: Charles Scribner's Sons, 1945): 282.

78 Avis Berman, Pearce inteview, op cit, p. 30 and Stavitsky, Pearce interview, p. 5.

79 Jack Cowart, *Roy Lichtenstein 1970-1980* (Hudson Hills Press in association with The Saint Louis Art Museum, 1981): 128 and e-mail, May 23, 2005 ("too finished and too derivative, likely store-bought.")

80 On Morris, see W. Jackson Rushing, *Native American Art and the New York Avant-Garde* (Austin: University of Texas Press, 1995): 90-96.

81 Ibid, pp. 137-55 and Gail Stavitsky, *Will Barnet: A Timeless World* (Montclair Art Museum, 2000): 22-30, 61-68 (essay by Twig Johnson).

82 Ibid. p. 148. In an interview with the authors, June 13, 2003, Will Barnet observed that, although he knew Lichtenstein, he never saw any of his Native American-themed work. Looking at reproductions of both the early and later works, Barnet found them to be truly compelling work by "a very probing artist who never loses sight of how to compose and put a picture together, as he opened himself to all the different cultures of our time and of the past——Design is obviously one of his great pleasures." He responded to Lichtenstein's *The End of the Trail* (Cat. Nos. 8. 9.) "as out of a Western movie." He also referred to the work in relation to the Indian Space movement as sharing "the directness and strength of Native American ceramics."

83 Gail Stavitsky, telephone interview with Chuck Csuri, October 19, 2004.

84 As per an e-mail from Carolyn Thum, June 21, 2004, Lichtenstein showed two drawings, *Cowboy and Indian* and *Emmigrant Train* in the show *Cleveland Drawings at the Cleveland Museum* (October 7-24, 1954). She explains that the museum had a collection of around 800 baskets, textiles, ceramics, katsinas, etc. which was mostly sent out for

small exhibitions at local schools and libraries. For some of these Northwest Coast and Southwestern works, see *Handbook: The Cleveland Museum of Art* (Cleveland: Cleveland Museum of Art, 1978): 406-407. Thum suggests that Lichtenstein may have had better luck at the Museum of Natural History, however, Carole Camillo of the Cleveland Museum of Natural History was unable to confirm what he could have seen in the 1950s when the "cultural anthropology collection was decidedly smaller than today." (e-mail, July 14, 2004).

85 Sterling Evans, ed., *American Indians in American History, 1870-2001: a companion reader* (Westport, Conn., London: Praeger, 2002): 109-110.

86 Jack Cowart suggested this "ambient" of the Cleveland Indians as a strong National League team in an e-mail of August 25, 2004. 1954 was their best season (Mira Shin, research e-mail, April 1, 2005, websites, *www.baseballlibrary/features/topteams/1954indians.stm*

87 Ernst Busche, op cit, Ch. IV, part 2, p. 61. See also p. 97 (same chapter) for his suggestion that "it can not be excluded that already at this point Lichtenstein—as later in the "Modern Paintings"—borrowed Indian patterns from 1920s Art Deco."

88 Frank Crowninshield (foreword), *Art of the Americas Art News Annual VIII* (New York: The Art Foundation, Inc., 1948): 30, 31, 58, 59, 85.

89 Julio Gonzalez, "Picasso sculpteur," *Cahiers d'Art* 6-7 (1936): 189-191. Sidney Chafetz, op cit, has commented on Lichtenstein's appreciation of Picasso's then little known, innovative Boisgeloup sculptures as evidence of his friend's "inquisitive mind and depth of knowledge."

90 Andrew Carduff Ritchie, *Sculpture of the Twentieth Century* (New York: The Museum of Modern Art, 1952): 29, il. 156.

91 Ibid, p. 144.

92 Avis Berman interview, op cit, pp. 57, 101.

93 Ernst Busche, op cit, Ch. V, pp. 20-21.

94 George Catlin, *Letters and Notes on the Manners, Customs, and Condition of the North American Indians* (London: G. Catlin, 1841, with numerous re-issues), plates 14-17, 20, 49, 87 (Sioux tribe member). These plates were brought to our attention by Justine Price in her unpublished "Annotated Bibliography for Roy Lichtensteinstein American Indian Paintings," 2004, p. 2.

95 The head of the figure to the right can be compared to Lichtenstein's wood sculpture *Head (Figure)*, 1951 (RLF, #4665).

96 Gail Stavitsky interview with Roy Harvey Pearce, op cit, p. 2.

97 *A Cherokee Brave* won a purchase prize in the Ohio Prints exhibition at Ohio State in 1953. See Mary Lee Cortlett and Ruth E. Fine, *The Prints of Roy Lichtenstein...*, op cit, p. 18.

98 Marvin C. Ross, *The West of Alfred Jacob Miller* (1837) (Norman: University of Oklahoma Press, 1951): 5, 7. See also pp. 18, 23, 191 for other relevant Sioux Indian subjects.

99 Ibid, pp. 14, 21, 143. See also Ernst Busche's discussions of Miller as a source for other Lichtenstein works of this period, Chapter IV, part 2, pp. 30, 43-44, 47, 59.

100 George Catlin, *Letters and Notes...*, op cit, plates 11, 20, Vol. II frontispiece (*Catlin painting Mandan Chief*). See also his *War Dance, Teton, Dekota,* (Indians dancing in front of tipis) reproduced in Clide Hollmann, *Five Artists of the Old West* (New York: Hastings House, 1953): 15, and Harold McCracken, *Portrait of the Old West*, op cit, pp. 57-59. We are indebted to Justine Price, op cit, for her research.

101 Justine Price, "Annotated Bibliography," op cit., updated 2005, p. 10, e.g. Henry Longfellow, *The Song of Hiawatha*, with illustrations by Frederic Remington (Boston and New York: Houghton, Mifflin, and Co., 1891), engraving for *The Son of the Evening Star*. For more on Remington, see Harold McCracken, *Frederic Remington Artist of the Old West* (Philadelphia, New York: J.B. Lipincott and Co., 1947).

102 S.G., "Roy Lichtenstein," *Art Digest* 27 (February 1, 1953): 18.

103 F[airfield] P[orter], "Roy Lichtenstein," *Art News* 51 (February 1953): 74.

104 Ibid. See also Emily Genauer, "Art Notes," *New York Herald Tribune*, January 31, 1953, p. 11.

105 R[obert] R[osenblum], "Roy F. Lichtenstein," *Art Digest* 29 (February 15, 1954): 22.

106 F[airfield] P[orter], "Lichtenstein's Adult Primer," *Art News* 53 (March 1954): 64.

107 Ibid.

108 Ibid. See also "Murch Oils Show Power of 'Things,'" *The New York Times*, March 11, 1954, p. 29.

109 "Pastels by Mimi Boyer at Bradley," *The New York Times*, January 9, 1957, p. 34.

110 M[artica] S[awin], "Roy Lichtenstein," *Arts* 31 (January 1957): 52.

111 J.S., "Roy F. Lichtenstein," *Art News* 55 (February 1957): 12.

112 Ibid.

113 See Ernst Busche, op cit, Ch. IV, part 2, pp. 44-45 (discussion of Lichtenstein's *Treaty of Traverse des Sioux*, ca. 1956) and pp. 46-47 (*A Bad Treaty*).

114 Ernst Busche, op cit, Ch. IV, part 2, p. 47 and "Saving a Vanishing Frontier Part-Creek Oilman spends Millions on Art of Indian Days," *Life* 36 (March 8, 1954): 78. See also Ernst Busche's discussion (pp. 70-77) about another *Life* magazine source for Lichtenstein, an article entitled "Opening of the West" (vol. 27, July 4, 1949, pp. 40ff.) On Nahl, see Moreland L. Stevens, *Charles Christian Nahl Artist of the Gold Rush 1818-1878* (Sacramento: E.B. Crocker Art Gallery, 1976): 68-69, passim and "Caleb Lyon's Bruneau Treaty," *Idaho Yesterdays* 13 (Spring 1969): 16-19 (copy courtesy of the Gilcrease Museum).

115 See Jean-Claude Lebensztejn, "Eight Statements: Roy Lichtenstein [et al]," *Art in America* 63 (July-August 1975): "I've always been interested in Matisse but maybe a little more interested in Picasso."

116 F.P., "Roy Lichtenstein," *Art News* 50 (January 1952): 67-"*Very Important Person* is a self-portrait as a knight."

117 J.S., "Roy Lichtenstein," *Art News*, February 1957, op cit., p. 12.

118 Louise Bruner, "Kindergarten Dept. Calls New Exhibit Doodling, Not Art," *Cleveland News*, March 1, 1952, p. 16.

119 Ibid and "Is it Art—or Dizzy? Town's in a Tizzy," *Cleveland News*, March 13, 1952, front page of *The Cleveland News* Home Magazine Edition. On the relative conservatism of Cleveland's regionalist art scene, see William H. Robinson et al, *Transformations in Cleveland Art 1796-1946* (Cleveland: The Cleveland Museum of Art, 1996) and Busche, Ch. I, op cit, pp. 12-13, confirmed in Gail Stavitsky telephone interviews with Sidney Chafetz, March 28, 2005 and Richard Anuskiewicz, April 1, 2005.

120 "Is It Art?..." op cit. and "Artist Draws His Answer," *Cleveland News*, April 12, 1952, p. 20. See also Ronald Day, "Liked Mrs. Bruner's views on Artist," *Cleveland News*, March 13, 1952, Editorial Page p. 6 "Lichtenstein deliberately treats his subjects in a child-like naïve way....typical of quite a few twentieth century artists who consciously return to primitive pictograms and child art in an attempt to capture a direct uninhibited interpretation of a subject. Lichtenstein's choice of subjects: 'Cowboy on Horseback,' 'Wild Indian,' 'Charging the Castle,' etc. is quite consistent with his use of child and primitive art symbols."

121 "America Flavors Show," *Cleveland News*, January 8, 1955, p. 6 See also Paul Metzler, "Trio at Art Colony," *Plain Dealer*, January 9, 1955, p. 30.

122 Michael Kimmelman, *Portraits Talking with Artists at The Met, The Modern, The Louvre and Elsewhere* (New York: Random House, 1998): 86.

123 Ibid, p. 84.

124 John Coplans, "An Interview with Roy Lichtenstein," 1963, op cit, p. 31.

125 Ernst Busche, op cit, Ch. IV, part 2, p. 108.

126 Ibid, pp. 109-110, 112 and Richard Aquila, *Wanted Dead or Alive...*, op cit, p. 8.

127 Frank Perls, "The last time I saw Pablo," *Art News*, July 1974, op cit, p. 46.

128 Christian Andrew, "Trying to Shock Himself," *The Christian Science Monitor*, September 18, 1969, p. 11, "my early work looks like Picasso, and looks as though I was highly influenced, whereas the Picassos that I do *purposely*, don't have that: They seem to be to me more live."

129 Henry Geldzahler, *Lichtenstein's Picassos: 1962-1964* (New York: Gagosian Gallery, 1988): n.p. See also Richard Brown Baker, op cit, Side one, tape 3, p. 2 and Avis Berman, "'Joy and Bravura and Irreverence,': Roy Lichtenstein and Images of Women," *Roy Lichtenstein: Classic of the New* (Kunsthaus Bregenz, 2005): 138-145.

130 John Gruen, "Roy Lichtenstein....," op cit, *Art News* March 1976, p. 42.

131 Ibid and David Schapiro, "High Unity...," 1970s op cit, p. 7.

132 Brenda Lynn Schmahmann, *Roy Lichtenstein's Critique...*, 1987 op cit, p. 107 and Lawrence Alloway, "Art," *The Nation*, June 2, 1979, p. 645.

133 See large clipping file of reviews, RLF and Jack Cowart, *Roy Lichtenstein: 1970-1980* (Hudson Hills Press, New York in association with the Saint Louis Art Museum, 1981): 126-133, 178 (exhibition checklist).

134 E-mail from Celia Skeeles, Amerind Library, The Amerind Foundation, Texas Canyon, Arizona. The term was coined in 1899 by Major John Wesley Powell at the Bureau of American Ethnology. It can refer either to a member of any of the aboriginal groups of the western hemisphere or any of the indigenous languages of these groups. See also William C. Sturtevant, *Handbook of North American Indians History of Indian-White Relations* Vol. 4 (Washington, D.C.: Smithsonian Institution, 1988): 1.

135 Quoted in Jackson Rushing, *Native American Art...*, 1995, op cit, p. 25. In an e-mail of May 23, 2005, Jack Cowart stated that he is "not aware of the derivation" of the terms "Amerind" and "Amerindian" which he did not assign to the works.

136 See Katherine Plake Hough and Michael Zakian, *Transforming the Western Image in 20th Century American Art* (Palm Springs, California: Palm Springs Desert Museum, 1992): 38,39.

137 Quoted in Jackson Rushing, op cit, p. 125.

138 Gail Stavitsky, phone interview with Olivia Motch, June 3, 2005. Motch observed that the titles were "not that serious" and mostly needed for cataloguing purposes. She does not recall the derivation of the term "Amerind."

139 Gail Stavitsky, phone interview with Tony Berlant, April 23, 2005 and e-mail, June 2, 2005. Berlant recalled that Lichtenstein was "not that involved in Native American art...he just liked the motifs he saw." Motch, op cit, concurs that it is possible that Lichtenstein saw the term "Amerind" on one of Berlant's invoices and could have decided to use it. In a phone interview with Gail Stavitsky of June 10, 2005, Berlant recalled that he used the term "Amerind" for his business because of its rarity—"it was exotic and distinctive." He affirmed that Lichtenstein acquired from him a small Navajo rug in ca. 1973 that was "more mechanical and precisionist" and resembled Lichtenstein's work.

140 Helen A. Harrison, "A Look at Lichtenstein's Rarely Seen Art," *The New York Times*, August 8, 1982, p. 1 and Lawrence Alloway, *Roy Lichtenstein* (New York: Abbeville Press, 1983): 84,87,99.

141 John Gruen, "Roy Lichtenstein...," *op cit, Artnews*, March 1976, p. 42.

142 Bernice Rose, *The Drawings of Roy Lichtenstein* (New York: The Museum of Modern Art, 1987): 43.

143 Ibid.

144 Lawrence Alloway, *Roy Lichtenstein*, 1983 op cit, p. 95 (*Amerind Composition II*, Cat. No. 34 is reproduced on p. 96).

145 "Lichtenstein, wit style," *The Journal* (Wisconsin), undated clipping, 1980, RLF (review of solo show at the University of Wisconsin-Eau Claire). See also Jack Cowart, *Roy Lichtenstein 1970-1980*, op cit,

p. 127: "Feeling that Indian forms establish a historical base for American art (reminding him of "primitive" African art's relationship to modern Cubist European art), the artist again willfully demonstrated in 1979 the dramatic flexibility of his style and choice by personally reinterpreting these subjects."

146 Brenda Lynn Schmahmann, *Roy Lichtenstein's Critique...*, 1987, op cit, p. 168. Olivia Motch, interview, op cit, also confirmed that Lichtenstein had possibly been going through his earlier works in storage for cataloguing purposes and starting to think about them.

147 Letter from Dr. Ernst A. Busche, June 15, 2005. Busche observes: *I think I might say that his taking up the American Indian subject matter [in 1979] was a kind of a result of my research on his early work....when Roy took up the American Indian motifs that was a bit like diving—very very carefully—back into that old, almost forgotten world, quite a courageous undertaking for him...He might have tested whether in his new situation... the old motif still did hold for him—at least his basic theme was still the same, American culture and history. But in the end that did not go very far.*

148 Ibid, pp. 168-9.

149 Ibid, p. 170: "The Cubists used [African Art] so much." See also Janis Hendrickson, *Roy Lichtenstein* (Cologne: Benedikt Taschen, 1988): 90.

150 Diane Waldman, *Max Ernst: A Retrospective* (New York: The Solomon R. Guggenheim Museum, 1975): 13, 57. See also *Totem* (1973) in Galerie Beyeler, *Max Ernst* (Basel: Die Galerie, 1974), pl. 71.

151 E-mail from Diane Waldman, June 17, 2005. Waldman also observed, "I think it is safe to say that my Ernst exhibition stimulated his interest in Surrealism and in Ernst in particular."

152 Stavitksy telephone interview with Diane Waldman, June 14, 2005.

153 Ibid.

154 Ibid.

155 Dawn Ades, *Dada and Surrealism Reviewed* (London: Arts Council of Great Britain 1978): 329.

156 Philip Smith, "Roy Lichtenstein: Interview," 1977, unpublished transcript, p. 2, RLF, in preparation for article in *Arts* 52 (November 1977): 26.

157 Brenda Lynn Schmahmann, *Roy Lichtenstein's Critique...*, 1987, op cit, p. 168.

158 *Roy Lichtenstein Graphic Work 1970-1980* (New York: Whitney Museum of American Art Downtown Branch, 1981): n.p.

159 Ibid.

160 Ibid.

161 Justine Price, transcript of interview with James de Pasquale, Senior Studio Assistant and Storage Manager for the Roy Lichtenstein Estate, December 10, 2004, p. 1.

162 Mark Rosenthal, transcript of interview, September 1990, RLF, p. 13.

163 Telephone interview with Gail Stavitsky, May 24, 2005. Reproduced in Bernice Rose, *The Drawings of Roy Lichtenstein...*, 1987, op cit, p. 129. Pasquale appeared as Lichtenstein's studio assistant in a film directed by Geoffrey Haydon in 1979 for the BBC (copy at RLF). Lichtenstein is featured in his Southhampton library creating the drawing for *Amerind Composition* (1979, sold at Sotheby's November 14, 2000, lot 37), then projecting it via a Portoscope projector onto a canvas, tracing the image, and creating the painting in the studio via a combination of stenciling and hand painting. He does not discuss the work at all, except to refer to his application of black as crucial to control and unify the work. This reference brings to mind the role of black form lines in Northwest Coast art.

164 E-mail from Dorothy Lichtenstein, April 13, 2005. She did not recall having seen Warhol's large collection of American Indian art in his home. For more information, see "The Andy Warhol Collection American Indian Art," *American Indian Art sale*, Sotheby's New York, April 28, 1988.

165 See Brenda Lynn Schmahmann, *Roy Lichtenstein's Critique...*, 1987, op cit, p. 127, for the dating of the series from April-September 1979. Also Deborah Solomon, "The Art Behind the Dots," *The New York Times Magazine*, op cit, 1987, p. 44 on Lichtenstein's friendship with Warhol whom he called a "tremendous force in art."

166 Ron Libertus, "Foreword," Walker Art Center, Indian Art Association, and The Minneapolis Institute of Arts, *American Indian Art: Form and Tradition* (New York: E.P. Dutton and Co., Inc., 1972): 6.

167 Seth M. Eastman, *Andy Warhol Plays Cowboys and Indians* (M.A. Thesis, University of Oklahoma, 2005): 9 (and Chapter II, passim). Neil Printz, Warhol catalogue raisonné project, April 26, 2005, e-mail. See also Patricia Janis Broder, *The American West The Modern Vision* (Boston: Little, Borwn,,and Co., 1984): 298-9. For Warhol's *Cowboys and Indians* series (1986), see Bill Berkson "Warhol's History Lessons," *Andy Warhol Cowboys and Indians Paintings and Drawings* (San Francisco: John Berggruen Gallery 2001): 3-5.

168 See for example, a reproduction of Robert Colescott's 1976 painted version of *The End of the Trail*, in Patricia Jean Trenton, *The West as Art: Changing Perceptions of Western Art in California Collections* (Palm Springs: Palm Springs Desert Museum, 1982), plate 82 (RLF library). See also Katherine Plake Hough and Michael Zakian, *Transforming the Western Image in 20th Century American Art* (Palm Springs, 1992), op cit, pp. 71-76 (Roy Lichtenstein), 76ff.

169 Authors' telephone interview with Dorothy Lichtenstein, November 18, 2004. Justine Price, interview with James de Pasquale, op cit, p. 2, "not aware of" Lichtenstein following the AIM activity; "he didn't go" to the Shinnecock reservation.

170 Gail Stavitsky, phone interviews of June 1 and 3 with Jonathan Holstein.

171 Ibid. Although there does not appear to be a copy of the catalogue for the Native American show in the Lichtenstein library, there is a copy of the Whitney's *American Folk Painters of Three Centuries* (1980), also referred to by Holstein as part of this re-evaluation of primitive art of which Lichtenstein was aware.

172 Jonathan Holstein, "Selective CV for the Montclair Art Museum Regarding Roy Lichtenstein," June 23, 2005, p. 2.

173 Ibid, pp. 2-3.

174 Ibid, p. 3.

175 Ibid.

176 Brenda Lynn Schmahmann, Roy Lichtenstein's Critique..., 1987, op cit, p. 169.

177 Ibid, p. 170.

178 Ibid, p. 169.

179 Ibid.

180 Ibid, p. 130 and Jack Cowart, *Roy Lichtenstein: 1970-1980*, op cit, 1981, pp. 108, 110-114, 121, 123-5.

181 William S. Rubin, *Dada, Surrealism and their Heritage* (New York: The Museum of Modern Art, 1968): 91.

182 See Jack Cowart, *Roy Lichtenstein...*, 1981, op cit, p. 58. Alfred Frankenstein's *The Reality of Appearance: The Trompe L'Oeil Tradition in American Painting* (New York Graphic Society Ltd., 1970) is in the RLF library.

183 See *Ancient Art of the Andes* (New York: The Museum of Modern Art, 1954): 75 and LeRoy H. Appleton, *American Indian Design and Decoration* (New York: Dover, 1971): 73.

184 Brenda Lynn Schamahmann, *Roy Lichtenstein's Critique...*, 1987, op cit,pp. 164, 171.

185 LeRoy H. Appleton, *American Indian Design and Decoration*, op cit, p. 67.

186 H. P. Mera, *Pueblo Designs: 176 Illustrations of the "Rain Bird*. (New York: Dover, 1970), frontispiece. See Brenda Lynn Schmahmann, *Roy Lichtenstein's Critique...*, 1987, op cit p. 135, 115-6, for further discussion of RL's use of standard, precoded signs for male and female, rational vs. irrational, Cubist vs. Surrealist.

187 Yellow is associated with the North, blue with the west, red to the South, white to the East, black and speckled areas are associated with Nadir and Zenith. These colors also correspond to the colors of the corn that the Pueblo people grow.

188 Brenda Lynn Schmahmann, *Roy Lichtenstein's Critique...*, 1987, op cit, p. 134.

189 Maria Naylor, ed., *Authentic Indian Designs* (New York: Dover, 1975): 31.

190 Jack Cowart, *Roy Lichtenstein: Sculpture & Drawings* (Washington D.C.: The Corcoran Gallery of Art, 1999): 16.

191 Whitney Museum of American Art, *Roy Lichtenstein: Graphic Work 1970-1980*, 1981, op cit, n.p.

192 See for example the entry for "Oeil" and juxtaposed reproduction of Magritte's *Portrait in Dictionnaire Abrégé Du Surréalisme* (Paris: Jose Corti, 1969): 19.

193 Mary Lee Cortlett and Ruth E. Fine, *The Prints of Roy Lichtenstein...*, op cit, pp. 36-37, 156-162.

194 Gail Stavitsky telephone interview with Ken Tyler, July 5, 2005. The print *A Cherokee Brave* was brought by Tyler from his own collection over to the print studio.

195 See Diane Waldman, *Roy Lichtenstein*, 1993, op cit, p. 251 and Jack Cowart, *Roy Lichtenstein 1970-1980*, op cit, p. 135. In an interview in September 1990 with Mark Rosenthal, Lichtenstein asserted "the Indian woodcuts that I did at Tyler...made me think about German Expresionist woodcuts, which I did at Gemini" (p. 13, RLF).

196 *Roy Lichtenstein: Graphic Work 1970-1980*, 1981, op cit, n.p. See also Brenda Lynn Schmahmann, *Roy Lichtenstein's Critique...*, 1987, op cit, p. 170 (Lichtenstein refers to his use of "canoe shapes" that American Indians "didn't really make.")

197 Jonathan Holstein, op cit, has referred to the possibility of Lichtenstein looking at such sources of standardized tourist images as the Fred Harvey catalogues of the Southwest with their images of the saguaro cactus, rainbird, bearpaw, and arrows. He has also referred to the 63 foot long Haida canoe (1878) at the American Museum of Natural History which would have interested Lichtenstein.

198 See the examples in LeRoy Appleton, op cit, p. 65.

199 See Schmahmann, op cit, p. 136 for a discussion of the *Amerind Landscape* tapestry edition as the return of a co-opted low art source to the domain of craft. See also D.S.S. Schaff, "Conversation with Roy Lichtenstein," *Art International* 23 (January 1980): 31 "...I've just done another one that's surrealist, American Indian surrealist, in a hooked rug."

200 "A Question of Appearances/talk with Roy Lichtenstein," *Connaissance des Arts*, March 1981.

201 Brenda Lynn Schmahmann, *Roy Lichtenstein's Critique...*, 1987, op cit, p. 124 and on Ernst, Loplop, and bird imagery, pp. 121-6, 131-3.

202 Brenda Lynn Schmahmann, *Roy Lichtenstein's Critique...*, 1987, op cit, pp. 131.

203 Ibid, p. 119.

204 Ibid, pp. 135,137.

205 RLF clipping files. In an e-mail of April 13, 2005, Diane Turco, Leo Castelli Gallery, visually confirmed the presentation of *Pow Wow Composition* (Ludwig Collection, Aachen) in the show which was on view from April 28 to May 19. Kuspit did not even mention the Amerind works in his extended, contemporaneous discussion of the Surrealist series, "Lichtenstein and the Collective Unconscious of Style," *Art in America* 67 (May-June 1979): 100-105.

206 Myriam A. Springuel, "Introduction," *Symbols and Scenes: Art by and About American Indians* (Washington D.C.: Corcoran Gallery of Art, 1980): n.p.-"Recently, Roy Lichtenstein has employed Indian elements in his compositions." In a letter of May 21, 2004, Marisa Bourgoin, Archivist, confirmed that there is no further information in the files and sent along a press clipping (*Washington Post*, March 6, 1980) which does not mention Lichtenstein.

207 Judd Tully, "Lichtenstein," *Horizon* (September 1981): 46.

208 Thomas Lawson, "Roy Lichtenstein Leo Castelli," *Flash Art* No. 90-91(June/July 1979): 6.

209 Helen A. Harrison, "Lichtenstein Uses Mirrors," *The New York Times*, November 4, 1979, Sec. XXI (Long Island), p. 23.

210 Kay Larson, "Art," *New York* (September 21, 1981): 34.

211 Paul Sutinen, "Roy Lichtenstein," *Fresh Weekly Willamette Week's Arts & Entertainment Guide* (March 4-10, 1980): 8 (review of show at Portland Center for the Visual Arts). RLF file.

212 Calvin Tomkins, "The Art World The Antic Muse," *The New Yorker* (August 17, 1981): 83.

213 Helen A. Harrison, "A Look...," *The New York Times*, 1982, op cit., p. 1 and John Russell, "Seeing More Than Just Fun in Lichtenstein," *The New York Times* (September 5, 1982), Section II, p. 17. Olivia Motch, interview, op cit, stated that Lichtenstein was at first "hesitant" to show his early work and was persuaded to do so when she asserted that "it's all connected."

214 Helen A. Harrison, op cit, p. 1.

215 John Russell, op cit, p. 17.

216 Vicki Goldberg, "Lichtenstein: Still Subversive After All These Years," *The New York Times*, September 19, 1993,Section 2, p.37. See Diane Waldman, *Roy Lichtenstein*, op cit, 1993 and RLF clipping file, espe-cially reviews by Michael Kimmelman, "On Top with Pop: Virtuoso of Irony," *The New York Times* (October 8, 1993): C1, C24 and Kay Larson,"Pop of Ages," *New York* (October 25, 1993): 101, which com-ment on the lack of earlier, pre-Pop work.

217 Roberta Smith, "A Surprise from Lichtenstein Prints Show," *The New York Times*, December 20, 1994, p. B1.

218 Brenda Lynn Schmahmann, *Roy Lichtenstein's Critique...*, 1987, op cit, pp. 171-2.

219 Roy Lichtenstein, quoted in Paul Sutinen, "Roy Lichtenstein," *Willamette Fresh Weekly*, March 4-10, 1980, op cit., p. 5.

220 Brenda Lynn Schmahmann, *Roy Lichtenstein's Critique...*, 1987, op cit, p. 112.

221 "A Question of Appearances (talk with Roy Lichtenstein,)" *Connais-sance des Arts* (March 1981):

222 Interview with Roy Lichtenstein conducted by Barbara Rose, undated, Research Library, The Getty Research Institute, Los Ange-les, (930100), transcript, p. 14, copy courtesy of Justine Price.

223 Whitney Museum of American Art, *Roy Lichtenstein Graphic Work 1970-1980*, op cit, n.p.

224 Ibid and Brenda Lynn Schmahmann, op cit, p. 170.

225 John Coplans, "An Interview...," *Artforum* 2 (October 1963): 31.

Checklist

1. *Indians with Travois*, ca. 1951
 Ink wash on paper
 21 3/4 x 28 in.
 Private Collection

2. *Untitled (Indians)*, ca. 1951
 Charcoal on paper
 22 3/8 x 30 3/4 in.
 Private Collection

3. *Untitled (Indian)*, 1950
 Pen and ink on smooth cream medium
 weight drawing paper
 8 1/2 x 6 in.
 Private Collection

4. *Indian and Buffalo*, ca. 1951
 Charcoal and wash drawing
 23 1/4 x 18 3/4 in.
 Private Collection

5. *The Death of Jane McCrea*, 1951
 Oil on canvas
 42 x 34 in.
 Lent by Lee Turner, P.A.

6. *The Last of the Buffalo II*, 1952
 Oil on canvas
 50 x 42 in.
 Lent by Lee Turner, P.A.

7. *The Assiniboins Attacking a Blackfoot Village*,
 ca. 1951
 Oil on canvas
 18 1/16 x 24 in.
 The Family of Hoyt L. Sherman

8. *The End of the Trail*, 1951
 Oil on canvas
 16 x 24 in.
 Private Collection

9. Variant Study for *The End of the Trail*, 1951
 Charcoal, gouache, watercolor,
 crayon, and black ink on paper
 15 3/8 x 19 7/8 in.
 Private Collection

10. Untitled decorative bowl with Indian
 motifs, ca. 1951
 Wood, incised, black infill
 6 x 16 3/4 in. diameter
 Lent by Maryellen Buckley

11. *Indian*, 1952-1953
 Wood, oil paint
 22 x 7 1/4 x 4 in.
 Lent by the Roy Lichtenstein
 Foundation

12. *Indian with Papoose*, 1952-53
 Carved wood
 30 3/4 x 9 x 4 in.
 Private Collection

13. *Untitled*, ca. 1955
 Mixed media: canvas, painted, laminat-
 ed wood, wood battens, screws
 27 3/4 x 33 1/4 in., variable dimensions
 Lent by Nina Hope, Julian Solotorovsky,
 Peter Solotorovsky, and Emilie Lapham

14. *Two Sioux*, 1952
 Oil on canvas
 30 x 22 1/16 in.
 Private Collection

15. *Two Sioux Indians*, 1952
 Woodcut on various drawing papers,
 including olive green Lana Ingres and
 gray Strathmore
 18 7/8 x 12 3/8 in.
 Ed. 8/10
 Lent by the Roy Lichtenstein
 Foundation

16. *A Cherokee Brave*, 1952
 Woodcut on cream laid paper
 Ed. 9/17
 19 1/16 x 14 13/16 in.
 Lent by the Roy Lichtenstein
 Foundation

17. *Two Indians (Two Indians with Birds)*, 1953
 Woodcut on medium weight,
 natural Japanese paper
 20 11/16 x 16 3/4 in.
 Ed. AP 2/6
 Private Collection

18. *Untitled (Indian with Papoose)*,
 ca. 1952
 Oil on canvas
 30 x 26 in.
 Private Collection

19. *Indian with Bird, I*, 1952
 Oil on canvas
 16 x 20 1/8 in.
 Private Collection

20. *Algonquins Before the Teepee*,
 ca. 1953
 Watercolor on paper
 30 x 22 in.
 Private Collection

21. *A Bad Treaty*, ca. 1956
 Oil and charcoal/crayon on canvas
 41 3/4 x 56 in.
 Lent by Nina Hope, Julian Solotorovsky,
 Peter Solotorovsky and Emilie Lapham

22. *A Winnebago*, ca. 1956
 Oil on canvas
 14 x 12 in.
 Private Collection

23. *The Chief*, 1956
 Lithograph on various papers, including
 heavyweight, cream wove, and Basing-
 werk Parchment
 21 3/8 x 16 7/8 in.
 Ed. unknown
 Private Collection

24. *Head with Braids*, 1979
 Oil and Magna on canvas
 50 x 40 in.
 Private Collection

25. *Face and Feather*, 1979
 Oil and Magna on linen
 36 x 36 in.
 Private Collection

26. *Composition with Two Figures*, 1979
 Oil and Magna on linen
 80 x 70 in.
 Private Collection

27. *Sketchbook F, page 5, Untitled Sketches for*
 Indian Design, ca. 1979
 Graphite on paper
 8 3/4 x 5 15/16 in.
 8 15/16 x 6 3/16 x 3/4 in.
 (sketchbook size)
 Private Collection

28. *Amerind Figure*, 1981
 Patinated bronze
 65 1/2 x 20 1/2 x 13 1/2 in.
 Ed. 3/3
 Private Collection

29. *Indian Composition*, 1979
 Oil and Magna on linen
 84 x 120 in.
 Private Collection

30. *American Indian Theme II*, 1980
 Woodcut on handmade Suzuki paper
 32 1/2 x 37 1/2 in.
 Ed. AP 6/18
 Private Collection

31. *Little Landscape*, 1979
 Oil and Magna on linen
 36 x 48 in.
 Private Collection

32. *Mythological Meeting*, 1979
 Oil and Magna on canvas
 36 x 50 in.
 Private Collection

33. *Amerind Landscape*, 1979
 Wool tapestry
 108 x 146 in.
 Ed. of 20
 Private Collection

34. *Amerind Composition II*, 1979
 Oil and Magna on linen
 64 x 100 inches
 Private Collection

35. Haida Model Totem Pole of British
 Columbia, ca. 1875
 Polychromed wood (Hydah Tree VIBC)
 written on wood on back
 47 5/8 x 5 1/2 x 3 in.Acquired by Roy
 Lichtenstein in 1994
 Private Collection

36. Wendell C. Bennett, with an
introduction by Rene D'Harnoncourt
Ancient Arts of The Andes
The Museum of Modern Art,
New York, 1954,
10 x 15 in. Features large vessel,
Coast Tiahuanaco, clay, 29 in. high
American Museum of Natural History
(p. 74)
Private Collection

37. *Catlin Portrays Indian Life*
From: James Truslow Adams, ed.
Album of American History, Volume II,
Charles Scribner's Sons, ©1945
11 x 14 1/2 in. (p. 282)
Private Collection

38. *Zuni Olla with "Rain Bird Design"*
Reproduced as frontispiece in H.P.
Mera, *Pueblo Designs: 176 Illustrations of
The "Rain Bird"*
New York: Dover Publications, Inc.,
1970 reprint
10 x 14 in.
Private Collection

39. George Catlin (1796-1872)
*North American Indian Portfolio
Group of Native American Indians from
Life, 1845*
Hand colored lithograph
23 1/2 x 18 1/2 inches
Montclair Art Museum,
Gift of Ruth Bannister in memory of
Lemuel Bannister
1981.23.1

40. George Catlin (1796-1872)
*North American Indian Portfolio
Buffalo Hunt, Chase, 1845*
Hand colored lithograph
18 1/2 x 23 1/2 inches
Montclair Art Museum,
Gift of Ruth Bannister in memory of
Lemuel Bannister
1981.23.6

41. George Catlin (1796-1872)
*North American Indian Portfolio
Buffalo Hunt, Chase, 1845*
Hand colored lithograph
18 1/2 x 23 1/2 in.
Montclair Art Museum,
Gift of Ruth Bannister in memory of
Lemuel Bannister
1981.23.7

42. George Catlin (1796-1872)
North American Indian Portfolio

Buffalo Hunt, Surround, 1845
Hand colored lithograph
18 1/2 x 23 1/2 in.
Montclair Art Museum,
Gift of Ruth Bannister in memory of
Lemuel Bannister
1981.23.9

43. George Catlin (1796-1872)
*North American Indian Portfolio
Buffalo Hunt, Dying Bull in a Snowdrift,
1845*
Hand colored lithograph
18 1/2 x 23 1/2 in.
Montclair Art Museum, Gift of Ruth
Bannister in memory of Lemuel
Bannister
1981.23.17

44. Cyrus E. Dallin (1861-1944)
Appeal to the Great Spirit, 1913
Bronze
21 1/4 x 21 1/2 x 14 1/2 in.
Montclair Art Museum, Bequest of
Florence O.R. Lang, 1943.34

45. *Headdress, ca. 1890-1910*
Plains, Blackfeet
Eagle feathers, felt, glass beads
15 1/4 x 11 x 19 in.
Montclair Art Museum, 0000.305

46. *Child's Tipi, ca. 1900*
Plains, Sioux
Hide, pigment, wood
28 x 16 in.
Montclair Art Museum, Gift of Mrs.
Henry Lang, in memory of her mother,
Mrs. Jasper R. Rand, 1931.445

47. *Jar, ca. 1880*
Southwest, Zuni
Clay, pigment
10 1/4 x 11 1/2 in.
Montclair Art Museum, Gift of Mrs.
Henry Lang in memory of her mother,
Mrs. Jasper R. Rand, 1931.372

48. *Olla, ca. 1880*
Southwest, Acoma
Clay, pigment
12 x 34 1/2 in.
Montclair Art Museum, Gift of Eliza-
beth Martin, 1960.60

49. *Bowl, ca. 1875*
Northeastern Woodlands, Iroquois
Wood
6 x 17 in.
Montclair Art Museum, Museum Pur-
chase, Acquisition Fund, 1955.19

50. *Bowl, ca. 1900*
Northwest Coast, Haida
Wood, pigment
4 x 5 3/4 in.
Montclair Art Museum, Gift of Mrs.
Henry Lang in memory of her mother,
Mrs. Jasper R. Rand, 1931.580

51. *Bow, ca. 1880*
California, Karok
Wood, pigment, hide
35 1/2 x 2 x 4 in.
Montclair Art Museum, Gift of Mrs.
Henry Lang in memory of her mother,
Mrs. Jasper R. Rand, 1931.303

52. *Roach, ca. 1890*
Plains, Sioux
Deer hair, porcupine guard hair, pig-
ment, metal, sinew, eagle feather
25 x 15 x 4 in.
Montclair Art Museum, Gift of Mrs.
Henry Lang in memory of her mother,
Mrs. Jasper R. Rand, 1931.469

53. *Cradleboard, ca. 1900*
Northwest Coast, Umatilla
Wood, hide, glass beads, brass nails,
cloth
37 1/2 x 15 3/4 x 7 in.
Montclair Art Museum, Gift of Mrs.
Henry Lang in memory of her mother,
Mrs. Jasper R. Rand, 1914.301

54. *Pitcher, ca. A.D. 1200*
Southwest, Ancestral Puebloan
Clay, pigment
4 1/2 x 4 in.
Montclair Art Museum, Gift of Miss
Alice Allan, 1934.25

55. *Rattles, ca. 1980*
Northwest Coast, Haida
Wood, pigment, stone
12 x 6 x 5 in. each
Montclair Art Museum, Museum pur-
chase, Acquisition Fund, 1985.66 A-B

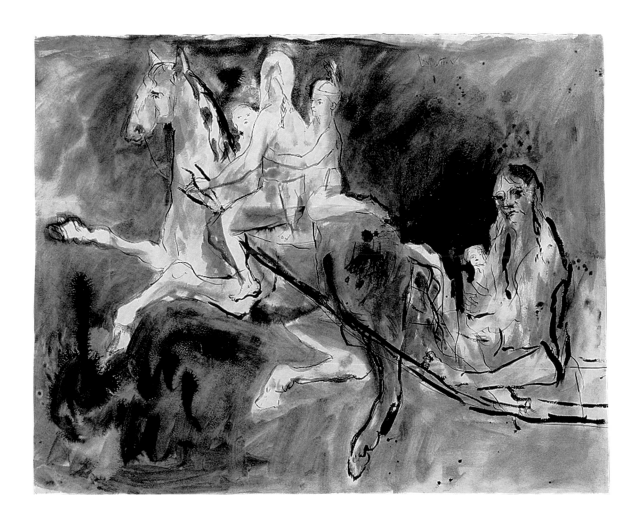

1. *Indians with Travois*, ca. 1951
Ink wash on paper
21 3/4 x 28 in.
Private Collection

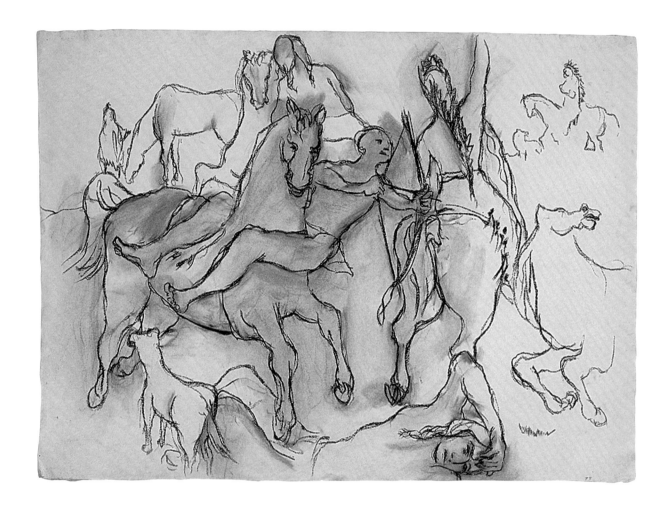

2. *Untitled (Indians)*, ca. 1951
Charcoal on paper
22 3/8 x 30 3/4 in.
Private Collection

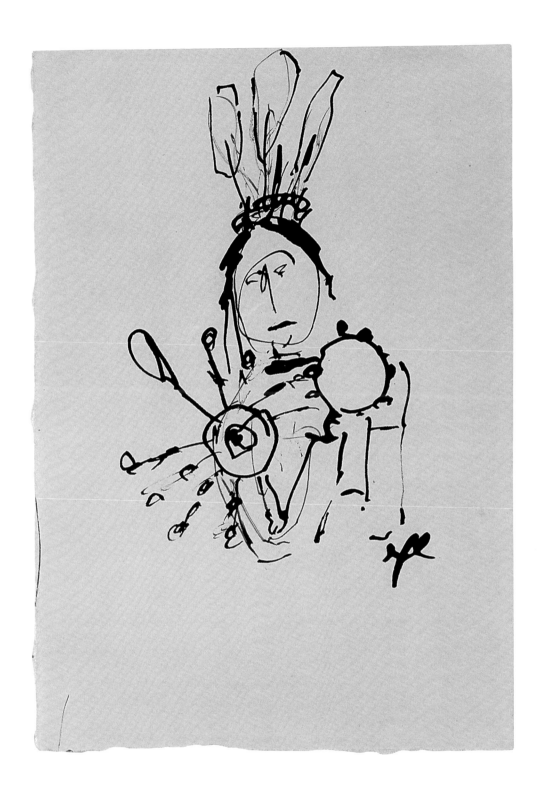

3. *Untitled (Indian)*, 1950
Pen and ink on smooth cream medium weight drawing paper
8 1/2 x 6 in.
Private Collection

4. *Indian and Buffalo*, ca. 1951
Charcoal and wash drawing
23 1/4 x 18 3/4 in.
Private Collection

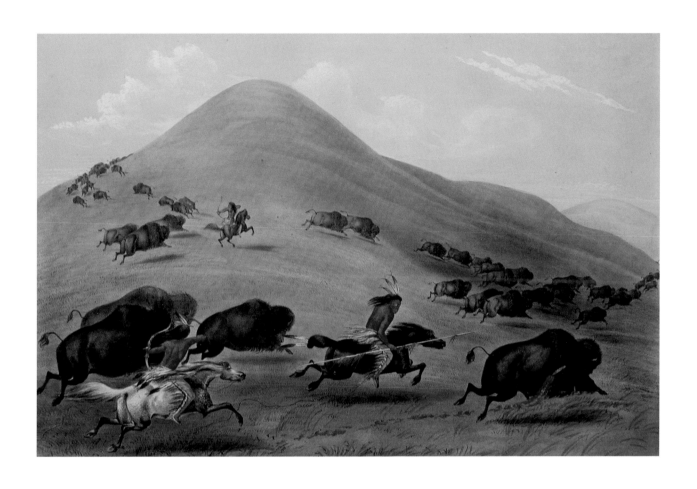

40. George Catlin (1796-1872)
North American Indian Portfolio
Buffalo Hunt, Chase, 1845
Hand colored lithograph
18 1/2 x 23 1/2 in.
Montclair Art Museum, Gift of Ruth Bannister in memory of Lemuel
Bannister
1981.23.6

43

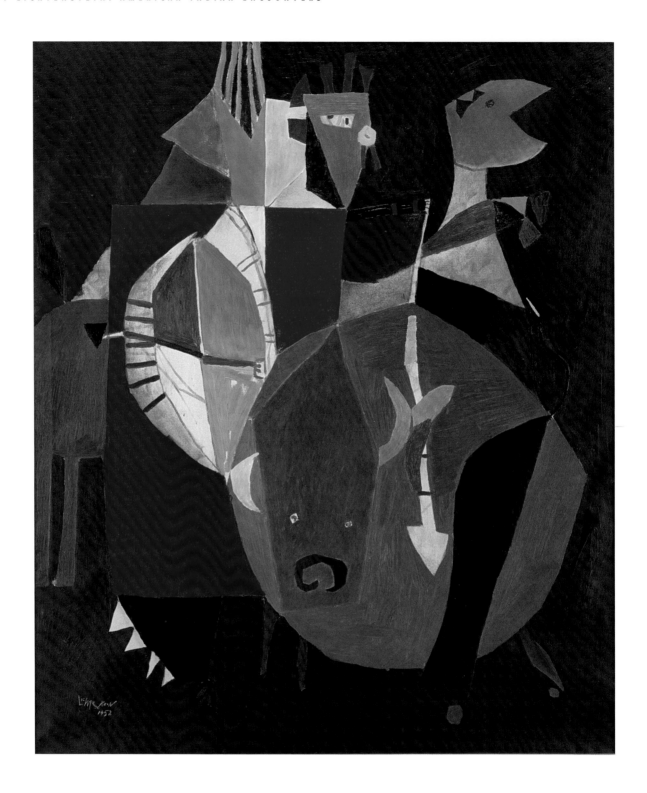

6. *The Last of the Buffalo II*, 1952
Oil on canvas
50 x 42 in
Lent by Lee Turner, P.A.
Photo: Geoffrey Wheeler ©2005

5. *The Death of Jane McCrea*, 1951
Oil on canvas
42 x 34 in.
Lent by Lee Turner, P.A.
Photo: Geoffrey Wheeler ©2005

8. *The End of the Trail*, 1951
Oil on canvas
16 x 24 in.
Private Collection

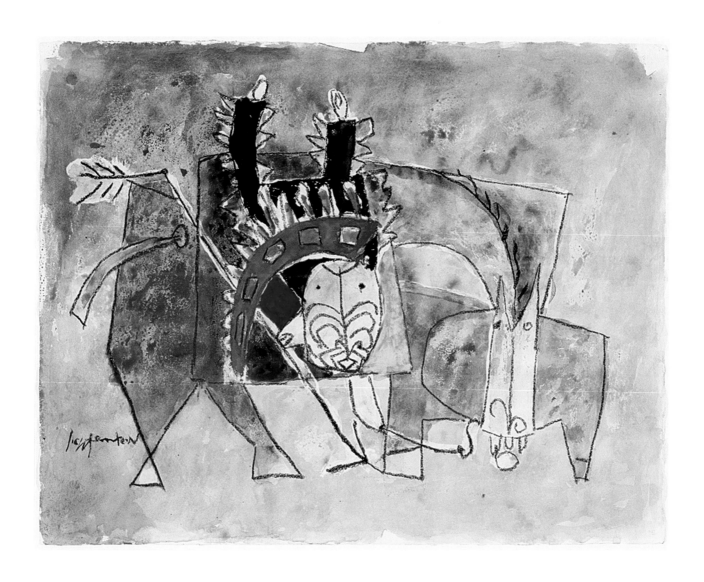

9. Variant Study for *The End of the Trail*, 1951
Charcoal, gouache, watercolor, crayon, and black ink on paper
15 3/8 x 19 7/8 in.
Private Collection

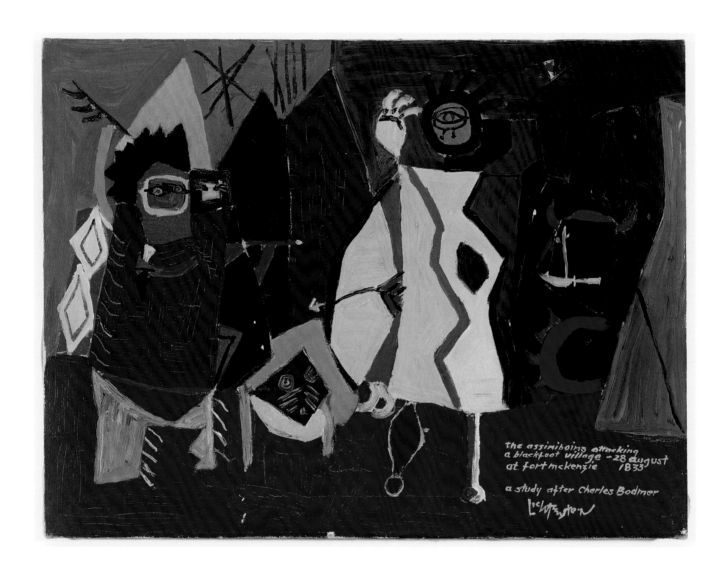

7. *The Assiniboins Attacking a Blackfoot Village*, ca. 1951
Oil on canvas
18 1/16 x 24 in.
The Family of Hoyt L. Sherman
Photo: Brian Forrest

21. *A Bad Treaty*, ca. 1956
Oil and charcoal/crayon on canvas
41 3/4 x 56 in.
Lent by Nina Hope, Julian Solotorovsky,
Peter Solotorovsky and Emilie Lapham

49

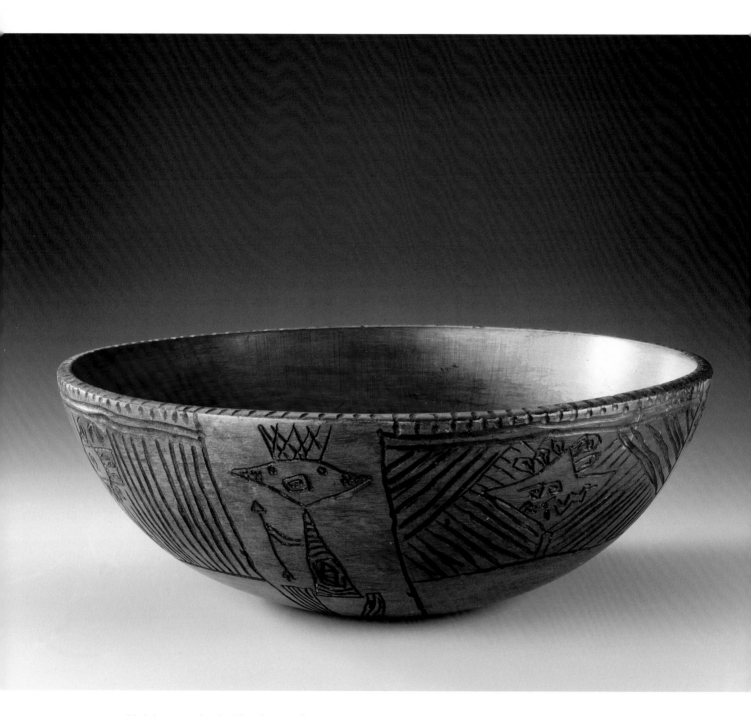

10. Untitled decorative bowl with Indian motifs, ca. 1951
Wood, incised, black infill
6 x 16 3/4 in. diameter
Lent by Maryellen Buckley

Catlin Portrays Indian Life

To Fort Union came all the surrounding tribes—enemies on the range, at peace at the Fort. The presence of a band of Crow Indians gave the artist an opportunity of sketching their mode of travel and of setting up their lodges.

Crows on the March

Note, *above*, the dogs as well as the ponies dragging lodge poles (the Indian travois) : And, *opposite*, the buffalo meat hung up to dry while the squaws scraped the skins.

Crow Lodges

From Fort Union, Catlin descended the Missouri to the Mandan Village near Fort Clark. Among these Indians he lived for some time, studying their way of life and transferring it to canvas.

Above, we see the interior of a Mandan dwelling. *Opposite*, is a drawing of the robe of Mahto-toh-pa recording his exploits against the Sioux and other enemies.

All illustrations shown on this page are from George Catlin, *Letters and Notes on the Manners, Customs, and Condition of the North American Indians.* 1841

37. *Catlin Portrays Indian Life*
From: James Truslow Adams, ed.
Album of American History, Volume II
Charles Scribner's Sons, ©1945
Reprinted by permission of the Gale Group
11 x 14 1/2 in. (p. 282, likely flagged by Roy Lichtenstein as source material)
Private Collection

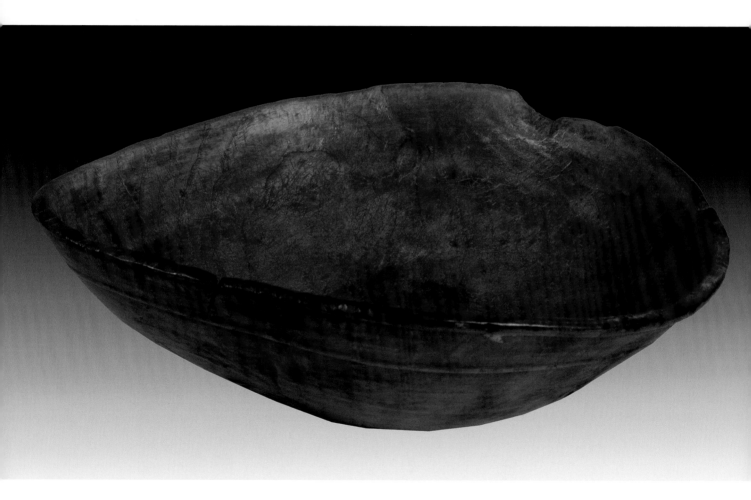

49. Bowl, ca. 1875
Northeastern Woodlands, Iroquois
Wood
6 x 17 in.
Montclair Art Museum, Museum Purchase, Acquisition Fund
1955.19

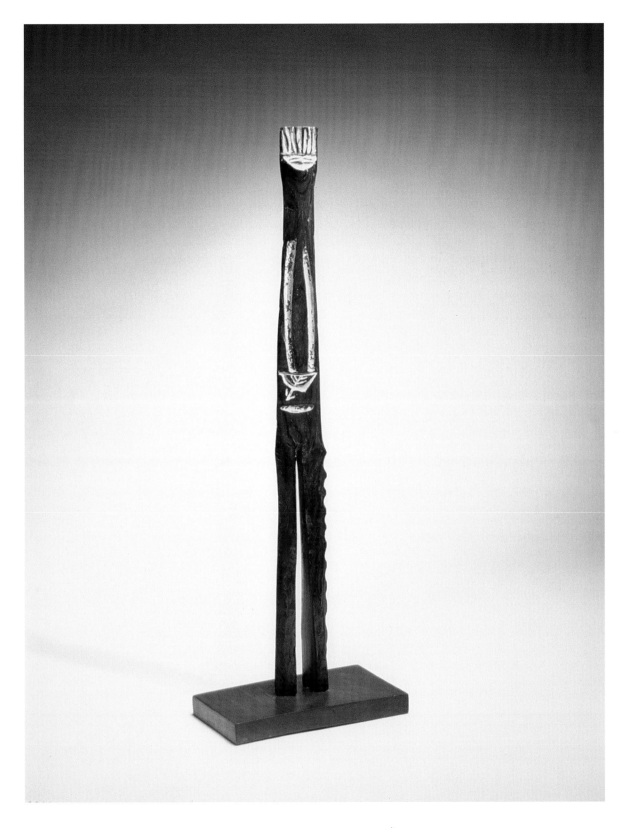

11. *Indian*, 1952-1953
Wood, oil paint
22 x 7 1/4 x 4 in.
Lent by the Roy Lichtenstein Foundation

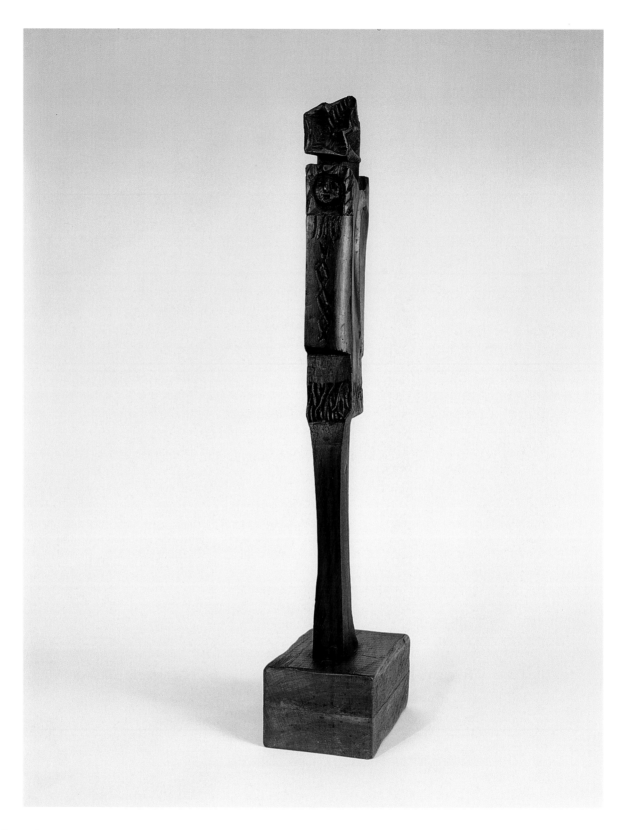

12. *Indian with Papoose*, 1952-53
Carved wood
30 3/4 x 9 x 4 in.
Private Collection

14. *Two Sioux*, 1952
Oil on canvas
30 x 22 1/16 in.
Private Collection

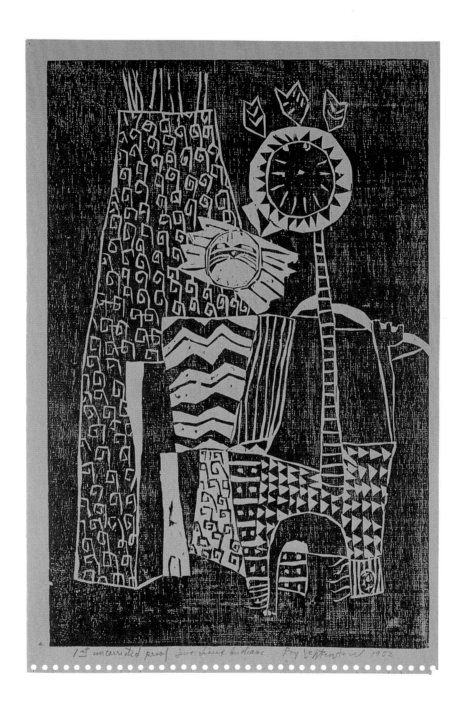

15. *Two Sioux Indians*, 1952
Woodcut on various drawing papers, including olive green Lana Ingres
and gray Strathmore
18 7/8 x 12 3/8 in.
Ed. 8/10
Lent by the Roy Lichtenstein Foundation

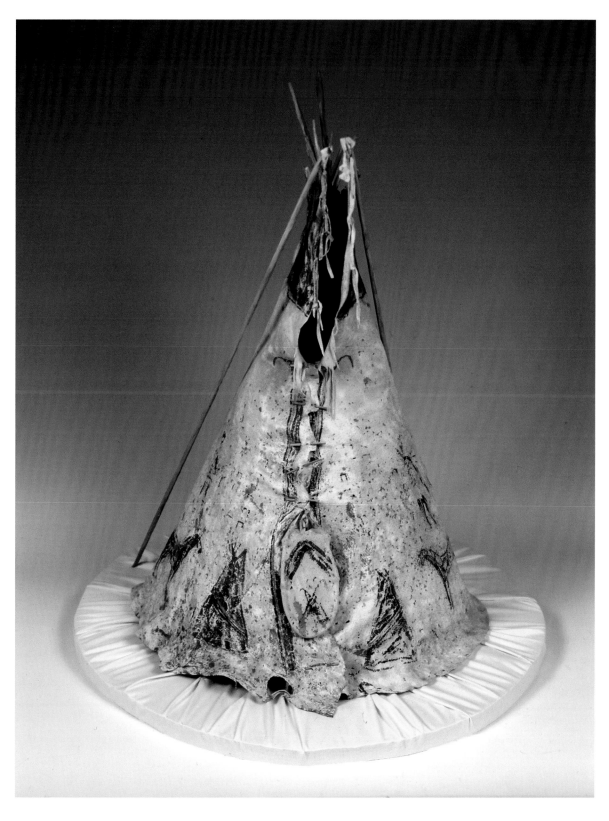

46. Child's Tipi, ca. 1900
Plains, Sioux
Hide, pigment, wood
28 x 16 in.
Montclair Art Museum, Gift of Mrs. Henry Lang, in memory of her
mother, Mrs. Jasper R. Rand,
1931.445

17. *Two Indians (Two Indians with Birds)*, 1953
Woodcut on medium weight, natural Japanese paper
20 11/16 x 16 3/4 in.
Ed. AP 2/6
Private Collection

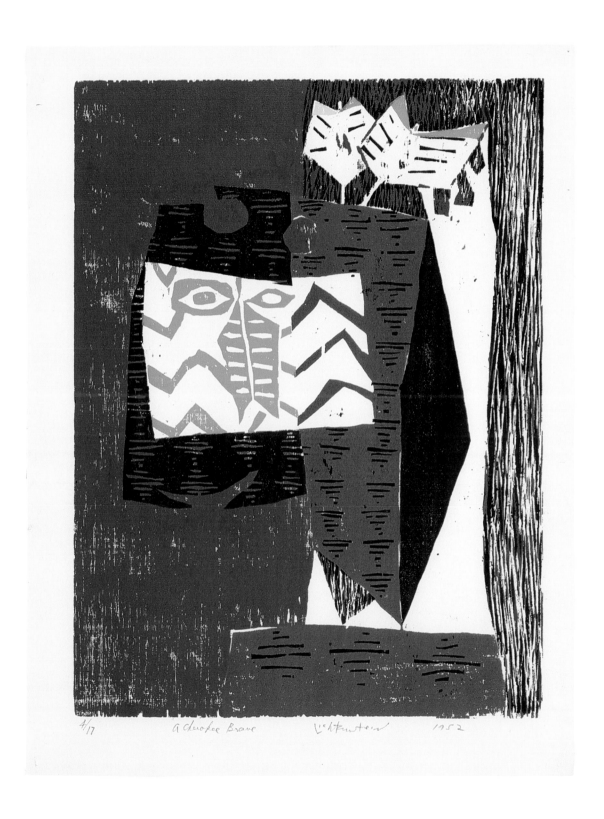

16. *A Cherokee Brave*, 1952
Woodcut on cream laid paper
19 1/16 x 14 13/16 in.
Ed. 9/17
Lent by the Roy Lichtenstein Foundation

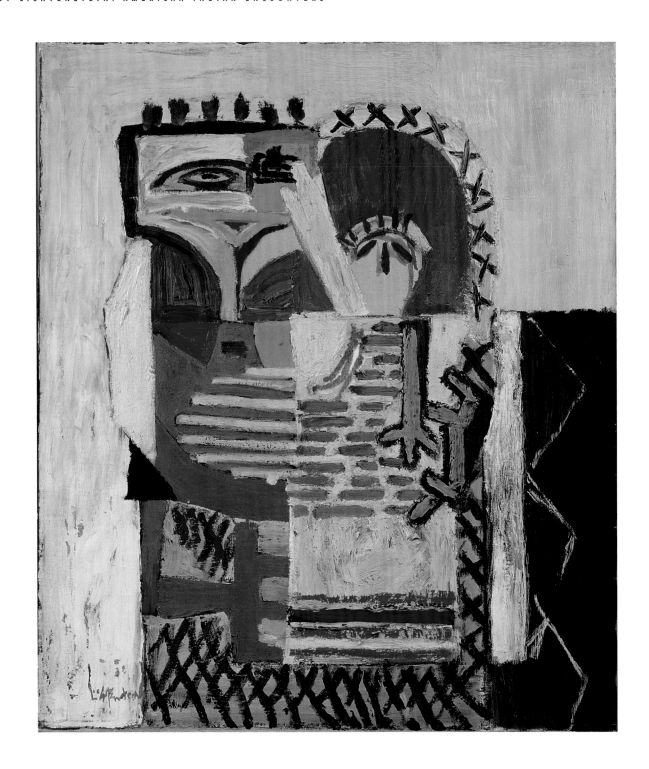

18. Untitled (Indian with Papoose), ca. 1952
Oil on canvas
30 x 26 in.
Private Collection

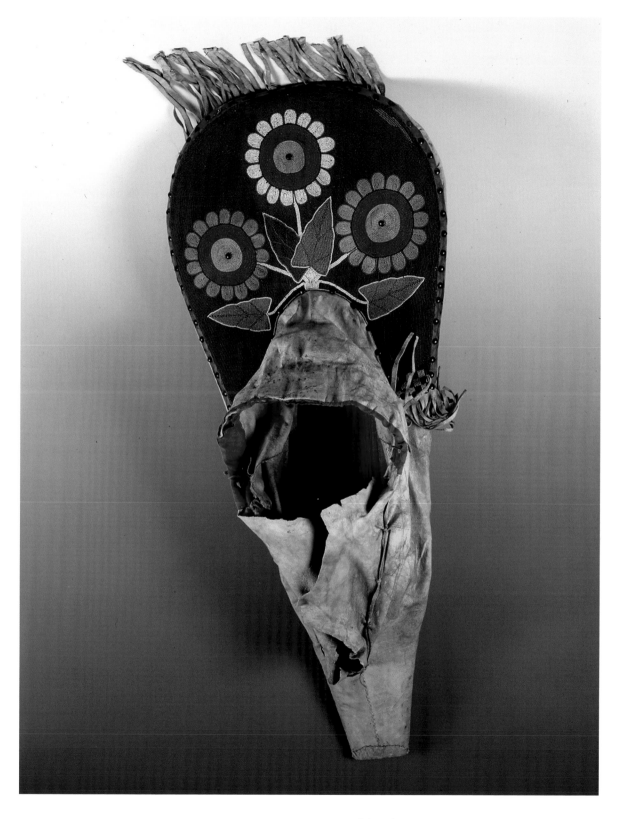

53. Cradleboard, ca. 1900
Northwest Coast, Umatilla
Wood, hide, glass beads, brass nails, cloth
37 1/2 x 15 3/4 x 7 in.
Montclair Art Museum, Gift of Mrs. Henry Lang in memory of her
mother, Mrs. Jasper R. Rand
1914.301

19. *Indian with Bird, I*, 1952
Oil on canvas
16 x 20 1/8 in.
Private Collection

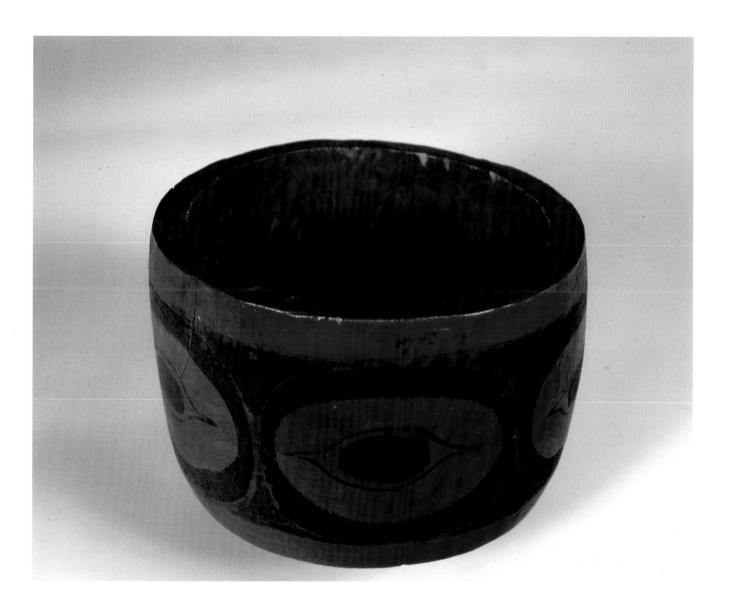

50. Bowl, ca. 1900
Northwest Coast, Haida
Wood, pigment
4 x 5 3/4 in.
Montclair Art Museum, Gift of Mrs. Henry Lang in memory of her
mother, Mrs. Jasper R. Rand
1931.580

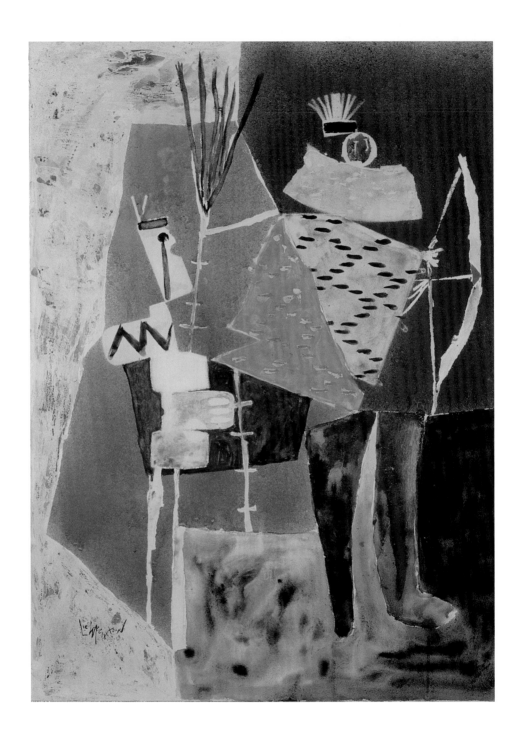

20. *Algonquins Before the Teepee*, ca. 1953
Watercolor on paper
30 x 22 in.
Private Collection

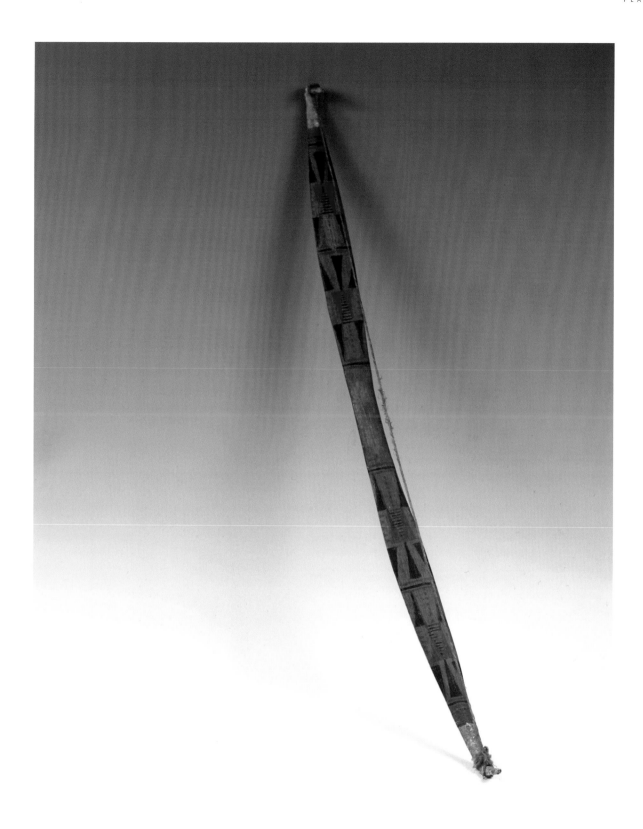

51. Bow, ca. 1880
California, Karok
Wood, pigment, hide
35 1/2 x 2 x 4 in.
Montclair Art Museum, Gift of Mrs. Henry Lang in memory of her
mother, Mrs. Jasper R. Rand
1931.303

65

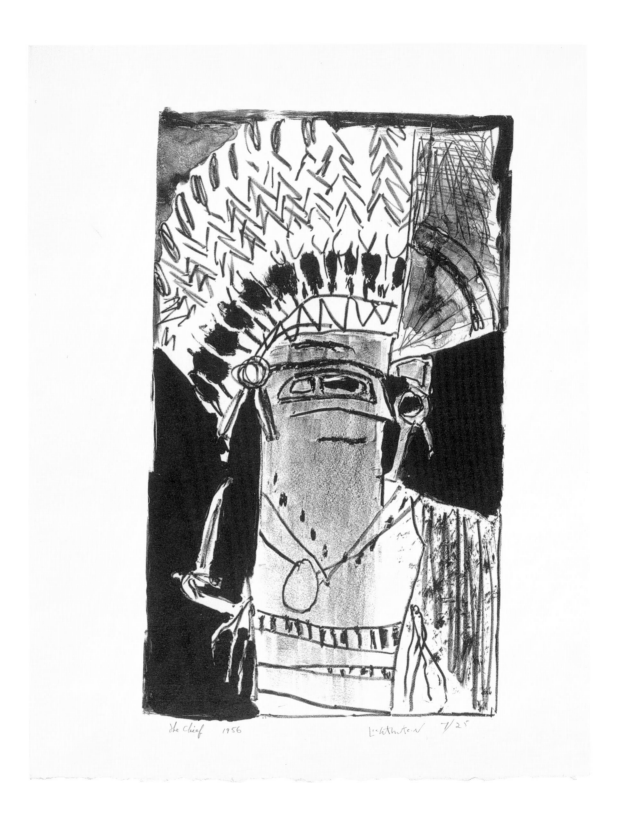

23. *The Chief*, 1956
Lithograph on various papers, including heavyweight, cream wove,
and Basingwerk Parchment
21 3/8 x 16 7/8 in.
Ed. unknown
Private Collection

45. Headdress, ca. 1890-1910
Plains, Blackfeet
Eagle feathers, felt, glass beads
15 1/4 x 11 x 19 in.
Montclair Art Museum
0000.305

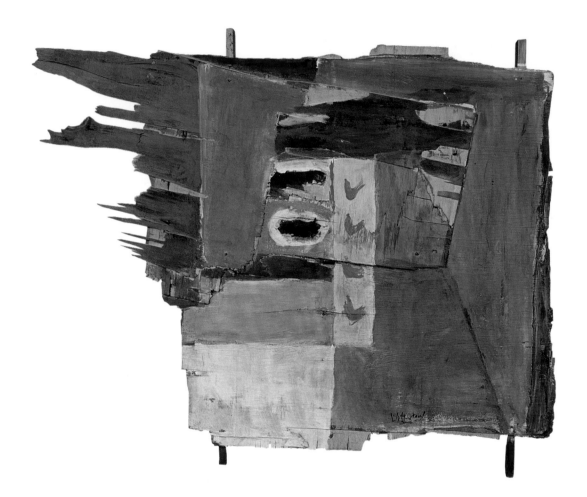

13. Untitled, ca. 1955
Mixed media: canvas, painted, laminated wood, wood battens, screws
27 3/4 x 33 1/4 in., variable dimensions
Lent by Nina Hope, Julian Solotorovsky, Peter Solotorovsky, and Emilie
Lapham

22. *A Winnebago*, ca. 1956
Oil on canvas
14 x 12 in.
Private Collection

24. *Head with Braids*, 1979
Oil and Magna on canvas
50 x 40 in.
Private Collection

29. *Indian Composition*, 1979
Oil and Magna on linen
84 x 120 in.
Private Collection
Photo: Robert McKeever

25. *Face and Feather*, 1979
Oil and Magna on linen
36 x 36 in.
Private Collection

Fig. 82. Large vessel. Coast Tiahuanaco. Clay, 29″ high. Collection: American Museum of Natural History. (41.0/5314)

36. Wendell C. Bennett, with an introduction by Rene D'Harnoncourt
Ancient Arts of The Andes
The Museum of Modern Art, New York, 1954
10 x 15 in.
Features large vessel with geometric mouth design, Coast Tiahuanaco, clay, 29 in. high, American Museum of Natural History (on p. 74, probably flagged by Lichtenstein as source material)
Private Collection

26. *Composition with Two Figures*, 1979
Oil and Magna on linen
80 x 70 in.
Private Collection

Zuñi olla with "Rain Bird" design.

38. Zuni Olla with "Rain Bird Design"
Reproduced as frontispiece in
H.P. Mera, *Pueblo Designs: 176 Illustrations of The "Rain Bird"*
New York: Dover Publications, Inc., 1970 reprint
10 x 14 in.
Private Collection

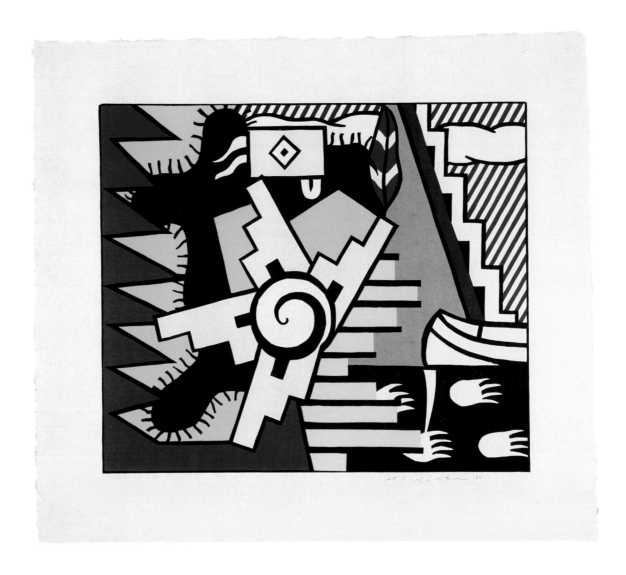

30. *American Indian Theme II*, 1980
Woodcut on Handmade Suzuki Paper
32 1/2 x 37 1/2 in.
Ed. AP 6/18
Private Collection

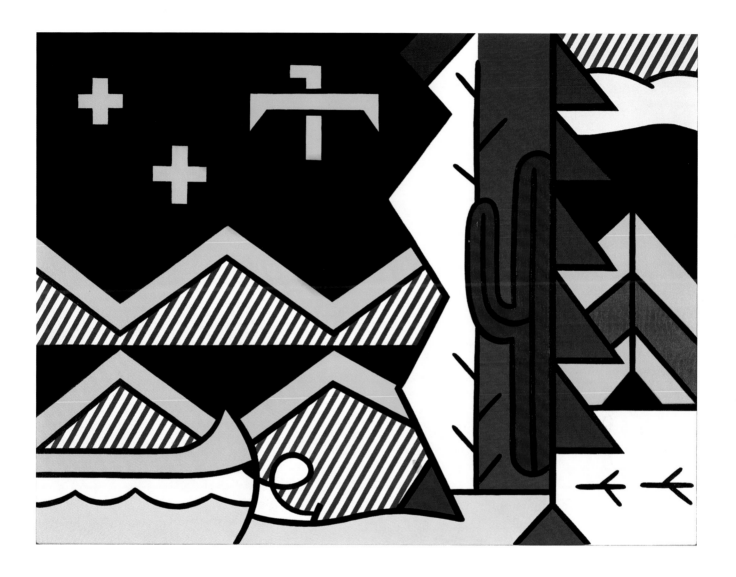

31. *Little Landscape*, 1979
Oil and Magna on linen
36 x 48 in.
Private Collection

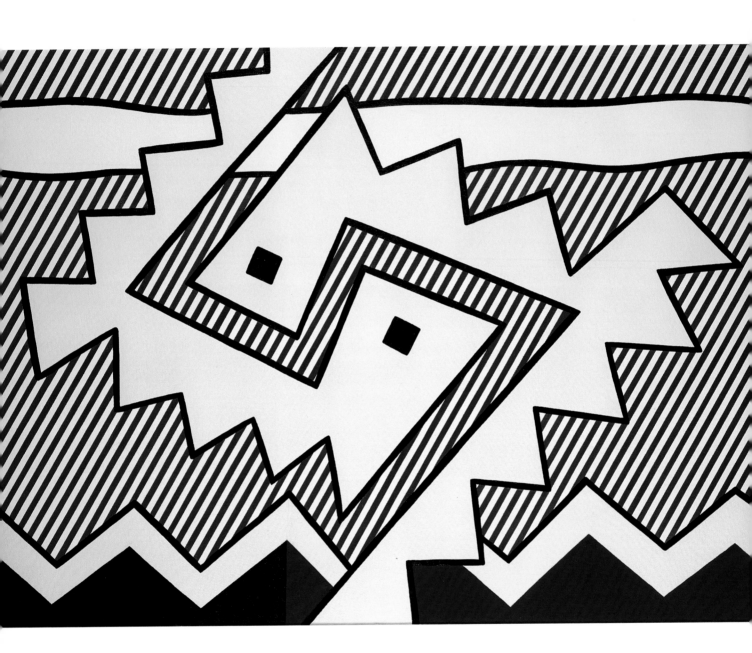

32. *Mythological Meeting*, 1979
Oil and Magna on canvas
36 x 50 in.
Private Collection

27. Sketchbook F, page 5, Untitled Sketches for Indian Design, ca. 1979
Graphite on paper,
8 3/4 x 5 15/16 in.
8 15/16 x 6 3/16 x 3/4 in. (sketchbook size)
Private Collection

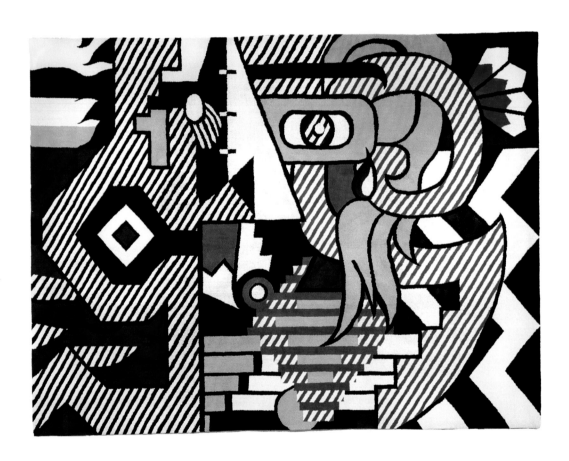

33. *Amerind Landscape*, 1979
Wool tapestry
108 x 146 in.
Ed. of 20
Private Collection

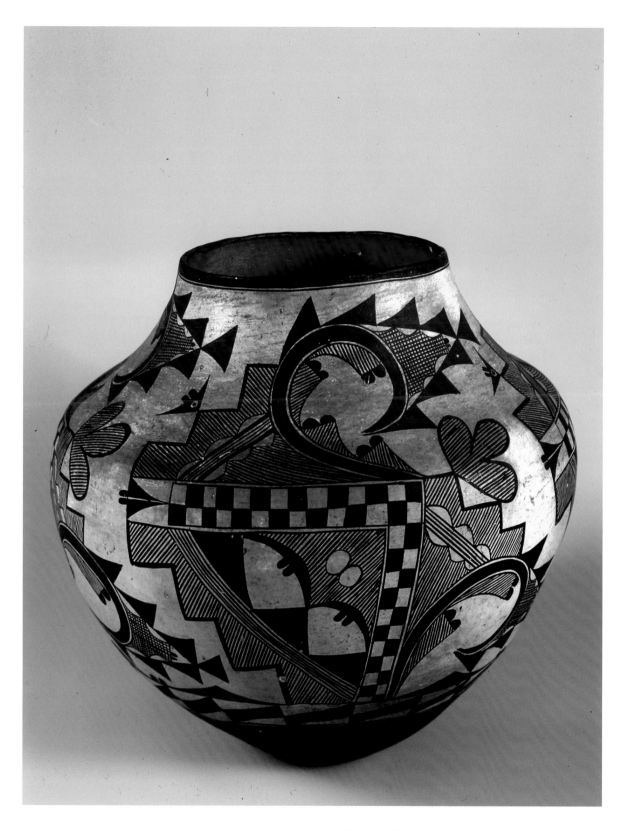

48. Olla, ca. 1880
Southwest, Acoma
Clay, pigment
12 x 34 1/2 in.
Montclair Art Museum, Gift of Elizabeth Martin
1960.60

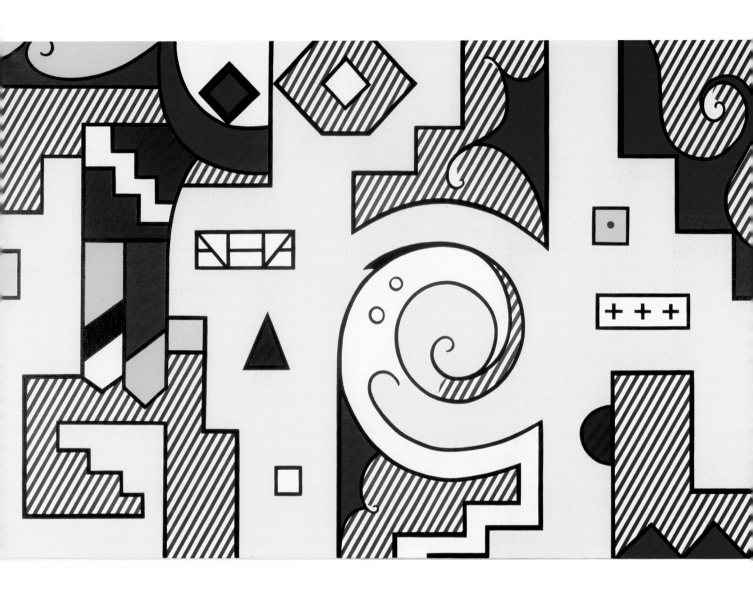

34. *Amerind Composition II*, 1979
Oil and Magna on linen
64 x 100 inches
Private Collection

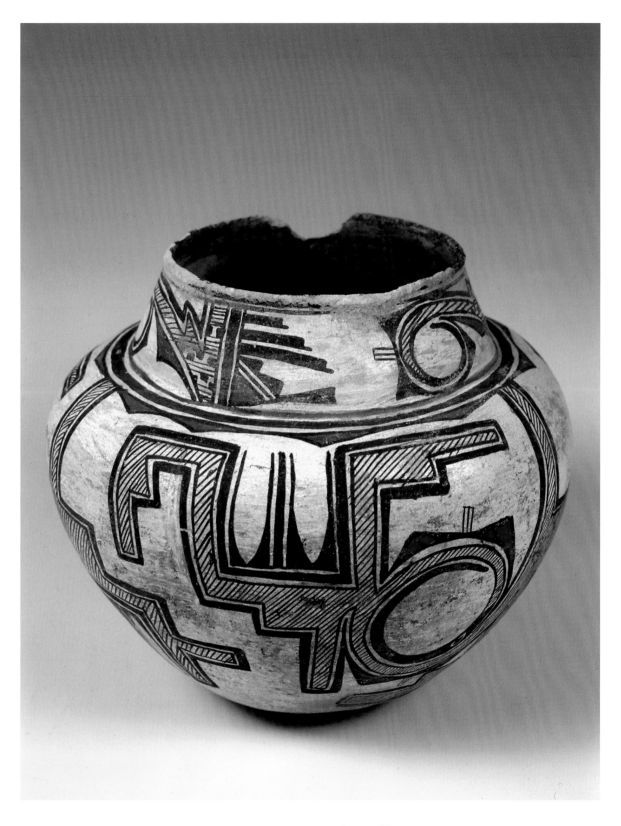

47. Jar, ca. 1880
Southwest, Zuni
Clay, pigment
10 1/4 x 11 1/2 in.
Montclair Art Museum, Gift of Mrs. Henry Lang in memory of her
mother, Mrs. Jasper R. Rand
1931.372

28. *Amerind Figure*, 1981
Patinated bronze
65 1/2 x 20 1/2 x 13 1/2 in.
Ed. 3/3
Private Collection

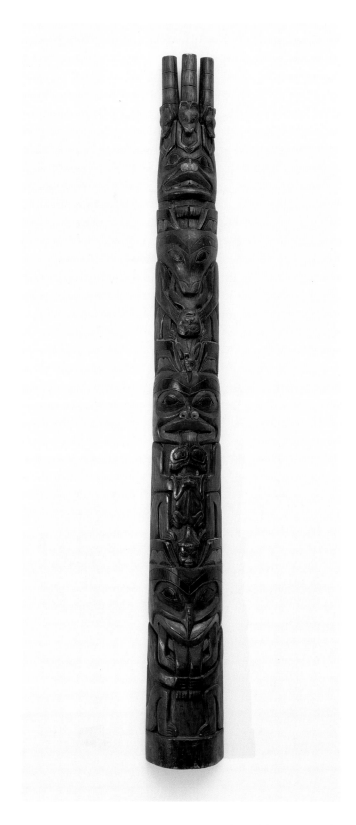

35. Haida Model Totem Pole of British Columbia, ca. 1875
Polychromed wood (Hydah Tree VIBC) written on wood on back
47 5/8 x 5 1/2 x 3 in.
Acquired by Roy Lichtenstein in 1994
Private Collection

52. Roach, ca. 1890
Plains, Sioux
Deer hair, porcupine guard hair, pigment, metal, sinew, eagle feather
25 x 15 x 4 in.
Montclair Art Museum, Gift of Mrs. Henry Lang in memory of her
mother, Mrs. Jasper R. Rand
1931.469

55. Rattles, ca. 1980
Northwest Coast, Haida
Wood, pigment, stone
12 x 6 x 5 in. each
Montclair Art Museum, Museum purchase, Acquisition Fund
1985.66 A-B

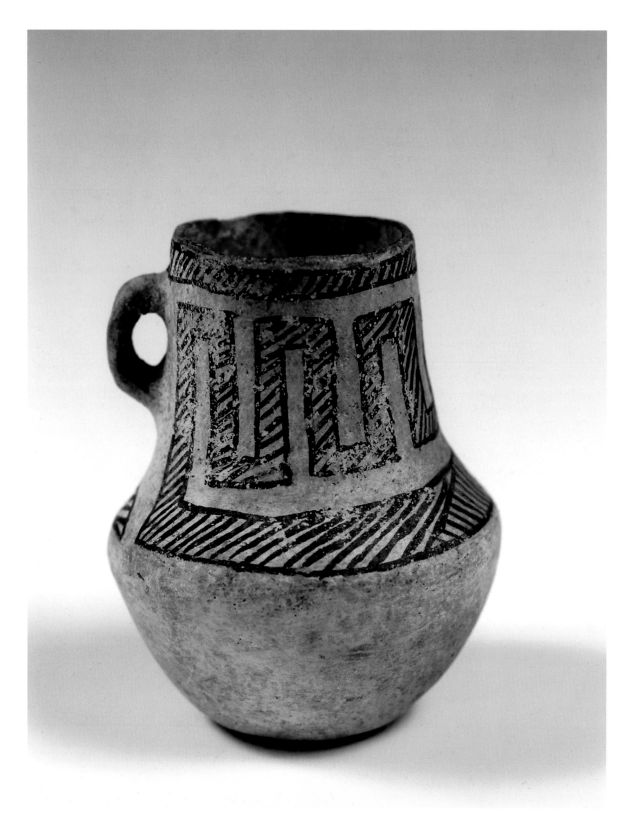

54. Pitcher, ca. 1200 A.D.
Southwest, Ancestral Puebloan
Clay, pigment
4 1/2 x 4 in.
Montclair Art Museum, Gift of Miss Alice Allan
1934.25

Appendix

Bibliography of Books on Native American and South American Art and Culture from Roy Lichtenstein's Southampton and Studio Libraries (in order of publication year, earliest first):

Album of American History, Volume II (1783–1853). New York: Charles Scribner & Sons, 1945.

> NB: The Foundation purchased the other volumes in this series, but this is the only one that was in Lichtenstein's personal collection, pp. 348–349, likely flagged by Lichtenstein. Also, pages 282–283 show reproductions from Catlin (Cat. No. 37).

Crowninshield, Frank (foreword), *Art of the Americas Art News Annual VIII* (New York: The Art Foundation, Inc., 1948).

Bennett, Wendell Clark. *Ancient Art of the Andes.* (New York: The Museum of Modern Art, 1954), pp. 12–13, 74–77, likely flagged by Lichtenstein. (Cat. No. 36)

Sides, Dorothy (Smith) and Smith, Clarice Martin, *Decorative Art of the Southwestern Indian.* (New York: Dover Publications, 1961 (1936).

Grant, Campbell. *The Rock Paintings of the Chumash.* (Berkeley: The University of California Press, 1965), pp. 114–115 flagged by Lichtenstein.

Chapman, Kenneth Milton and Harlow, Francis Harvey, *The Pottery of San Ildefonso Pueblo.* (Albuquerque: University of New Mexico Press, 1970).

Mera, H.P. *Pueblo Designs: 176 Illustrations of The "Rain Bird".* (New York: Dover, 1970). (Cat. No. 38)

Appleton, Le Roy H. *American Indian Design and Decoration* (formerly, *Indian Art of the Americas*). (New York: Dover, 1971 (1950).

The American Indian Observed. (New York, M. Knoedler & Co., 1971).

Walker Art Center, Minneapolis Institute of Arts, and Indian Art Association. *American Indian Art: Form and Tradition* (New York: E.P. Dutton and Co., Inc., 1972).

Fewkes, Jesse Walter. *Designs on Prehistoric Hopi Pottery.* (New York: Dover, Publications, 1973).

The World of the American Indian. (Washington, D.C., The National Geographic Society, 1974).

Newcomb, Frank Johnson and Reichard, Gladys Amanda, *Sandpaintings of the Navajo Shooting Chant.* (New York: Dover Publications, 1975).

Naylor, Maria, Ed., *Authentic Indian Designs: 2500 Illustrations from Reports of the Bureau of American Ethnology.* (New York: Dover Publications,1975).

Giammattei, Victor Michael et al. *Art of a Vanished Race: The Mimbres Classic Black on White.* (Silver City, NM): High Lonesome Books, 1975).

Berlant, Anthony, et al. *Walk in Beauty: The Navajo & Their Blankets.* (Boston: New York Graphic Society, 1977).

The Ulfert Wilke Collection: African Oceanic Pre-Columbian American Indian. (New York: Pace Primitive & Ancient Art, 1978).

Holstein, Philip M. et al. *Enduring Visions: 1000 Years of Southwestern Indian Art: An Exhibition.* (Aspen, Colo.; New York, N.Y: The Center; distributed by Publishing Center for Cultural Resources, 1979).

Goldstein, Marilyn M. *Ceremonial Sculpture of Ancient Veracruz.* (Brookville, N.Y.: Hillwood Art Gallery, Long Island University, 1987).

Berls, Janet Cathering, et al. *Plains Indian Drawing, 1865–1935.* (New York: Harry N. Abrams with the AFA Drawing Center, 1996).